Brush Lettering

An Instructional Manual
in Western Brush Calligraphy

Marilyn Reaves and Eliza Schulte

Design Books

We dedicate this book to our teachers and our students, who have inspired and challenged us, and to our families and friends for their patience and loving support.

Historical samples courtesy of the Newberry Library, Chicago.

Illustrations by Marilyn Reaves and Eliza Schulte, unless otherwise credited.

Printed in the United States of America

Designed by Marilyn Reaves and Eliza Schulte

Production: Ken Gross

Library of Congress Cataloging-in-Publication Data

Reaves, Marilyn.
 Brush lettering : an instructional manual in western brush calligraphy / Marilyn Reaves and Eliza Schulte.
 p. cm.
 Includes index.
 ISBN 1-55821-269-8
 1. Calligraphy. 2, Brush drawing. I. Schulte, Eliza. II. Title
NK3600.R38 1994
745.6'1—dc20 93-37176
 CIP

Published by Design Books

Design Books are distributed by
National Book Network
15200 NBN Way
Blue Ridge Summit, PA 17214

10 9 8

Contents

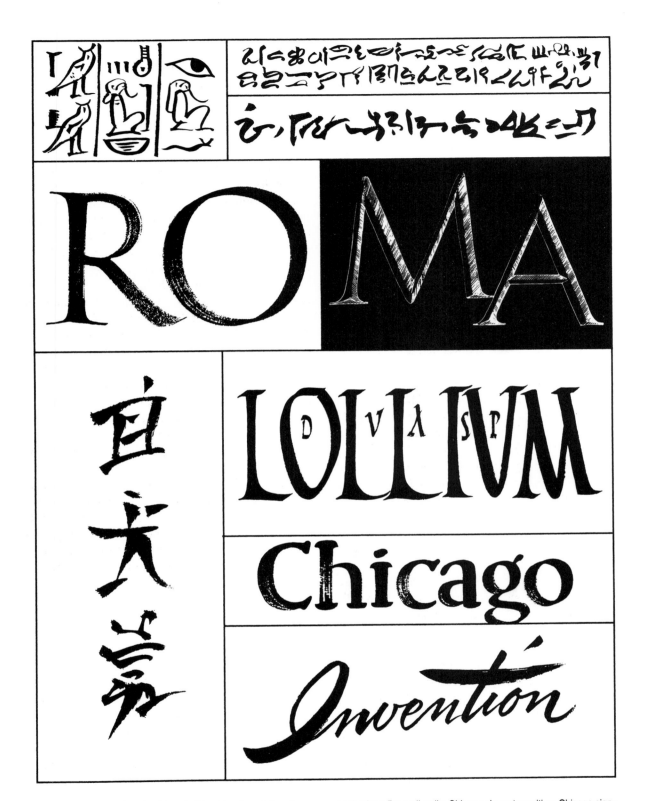

I-1. Facsimile writing: Egyptian hieroglyphics, hieratic script, and demotic script; painted roman caps and incised roman caps; brush rustics from Pompeii walls; Chinese character writing; Chicago sign-painting style; pointed-brush script from the 1940s.

Introduction

The pen, square cut and crafted from a hollow reed or bird's quill, is usually associated with the development of writing in the West. But the brush also played an early and important role in written communication. The Egyptians, as early as 3000 B.C., used a kind of brush with ink on papyrus in their hieroglyphic writing (and later in the more cursive styles of hieratic and demotic writing). Their brush was a rush or reed that had been frayed at one end by chewing or hammering and cut across the tip to make an "edged" tool for writing; it had some flexibility, and the multiple fibers could hold plenty of ink.

The Greeks also used brushes before introducing reed pens. Shaded writing (letters with thick and thin parts) with the reed pen was invented by the Romans in the second or third century B.C. They later also used a chisel-edged (or flat) brush with hair, which permitted them to write easily on large stone surfaces. Father Edward Catich, in his thorough and eloquent study of the roman capital letter, *The Origin of the Serif,* proposed that monumental letters were first painted on marble, then incised; and that the brush itself, a flexible, sophisticated tool that responded to pressure, dictated the development of the refined roman capital letterforms with their bracketed serifs.

A more casual kind of lettering, brush rustics, was a concurrent sign-painting style, used for public notices written on walls (rustics were also pen-written in manuscript). The black or red painted letters were compressed capitals with heavy "feet," often written with directness and spontaneity; examples can still be seen on the walls at Pompeii and Herculaneum.

Brushes made from animal hairs (and from feathers) were also used in the East. The Chinese used pointed brushes with bamboo handles as early as the fifth or sixth century B.C., and they were the first to write on paper. The pointed brush was appropriate to the pressure strokes of their ideogrammic character writing.

Direct brush writing—that is, writing in which each stroke constitutes a letter part—fell out of use in the West and did not see a revival until around 1890 in the Chicago style of sign painting. (Brushes, of course, had continued to be used in painting, decoration, and built-up, or drawn, lettering.) With renewed interest in calligraphy, the edged brush has also been embraced as a writing tool: styles relate more closely to historical penmade forms, but techniques are drawn from sign painting as well as pen-and-ink.

A newer style of brush writing is the pointed-brush script. Print advertising in the United States in the late 1930s and the 1940s turned to freely written brush scripts to replace the italic headlines that had been popular. The informal brush headlines, which also extended to penmanship styles, contrasted strongly with the straightforward body type. The pointed brush tool and the technique of applying and releasing pressure certainly owed a debt to Eastern brush writing, but the letterforms and styles (based on italic and copperplate) were in the Western tradition.

Contemporary brush writing shows the influence of many sources and traditions: monumental brush writing of the Roman Empire, historical pen writing, sign painting, Oriental pointed-brush writing, and even modern-day handwriting. In it we have a marriage of structure and inventiveness that has room for many voices and expressions.

Brushwork Today

Today the brush is a tremendously useful tool for any calligrapher or graphic artist: speed, directness, and versatility are its premier advantages. Whether you have a background in pen calligraphy, have used brushes as a painter or craftsperson, or have no lettering experience at all, with a little practice you can find myriad applications for brush lettering and brush design.

Brushes are a natural answer for many art projects that include lettering—watercolor or acrylic painting,

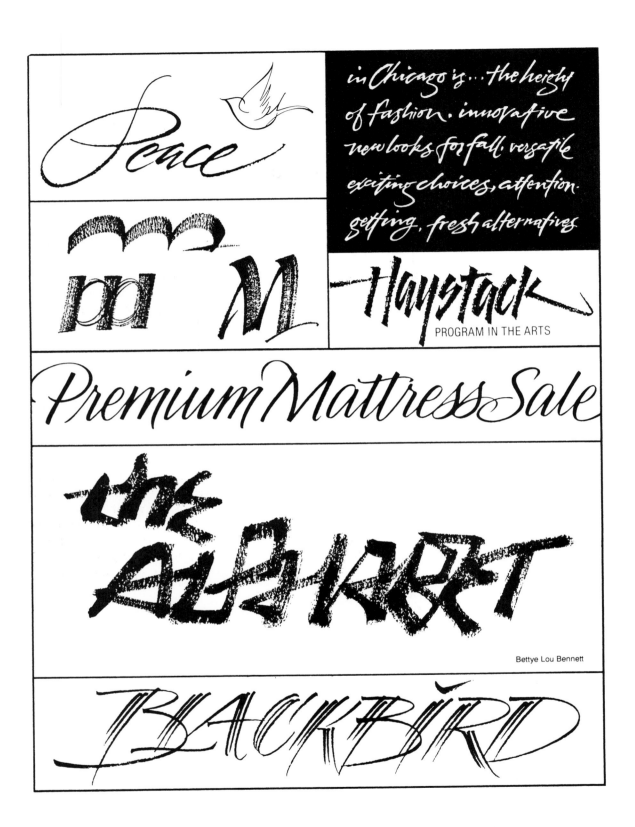

in Chicago is...the height of fashion. innovative new looks for fall. versatile exciting choices, attention. getting, fresh alternatives

Peace

Haystack
PROGRAM IN THE ARTS

Premium Mattress Sale

the ALPHABET

Bettye Lou Bennett

BLACKBIRD

I-2. Examples of contemporary brush lettering.

handmade books, silkscreen posters, banners and hangings, ceramics decoration, and fabric design are but a few. The graphic designer will find the brush a useful tool for creating unique letterforms and illustrations. Many examples of the commercial use of brush lettering are in evidence today, in packaging, advertising headlines, logo designs, compact-disk covers, movie titles, book-jacket titles, headings in brochures and annual reports, posters and signs, even contemporary certificates and awards. Brush lettering provides an eye-catching contrast to type; it can convey mood or communicate a message without the support of a drawing or photograph.

In its many applications, the brush has certain advantages over the pen. The chisel-edged brush comes in large sizes and can cover large areas, whether laying down a background wash or making big letters. A long-bristled brush can carry a lot of paint when it is fully loaded and does not depend on the capacity of a reservoir, as a pen does. With the edged brush, you can vary the stroke with subtle swelling or tapering simply by adjusting pressure; this can give interest and refinement to the letters.

With one pointed brush you can make letters that are very delicate and lightweight or letters that are bold and heavy, depending on how much pressure you apply; you can also vary the size from very small to large. With a pen, by contrast, you would have to use several different-size nibs to achieve similar effects. The pointed brush also allows you to make large letters using pressure and the side of the brush and to add refinements using the tip.

You can use either kind of brush, pointed or edged, with a variety of media—ink, watercolor, gouache, acrylics, enamel, poster paint, masking fluid—mixed to different consistencies (to flow in a pen, a medium must be fairly thin or watery). Because a brush is flexible and can be handled with a very light touch, it will write on almost any surface, from bond paper to fabric to a brick wall (penwork usually requires a sized paper with a slight tooth).

With a brush you can work at high speed to produce writing that is flowing and spontaneous, and you can achieve a variety of textures in the stroke. Speed and a light touch also make flourishing your letters easy and natural. The brush will ride across the surface of the paper, whereas a pen might lose contact, snag, or meet resistance. You can use many different grips and positions with the brush, and your ink or paint will still flow to the writing surface, allowing you more freedom in creating innovative strokes or letterforms. With some practice you will find that speed allows you to imitate the flow and contours of handwriting, to move in many directions, and even to change direction within a stroke.

Because the brush is sensitive to the slightest change of pressure, the possibilities for alphabet design are magnified; the imaginative lettering artist can produce a wide variety of expressive styles. Controlled work, such as drawing, outlining, drop shadows, or patterning, will also come as you gain control of the tool. The personal styles that many lettering artists have evolved (as shown in chapter 6) attest to the great versatility of the brush as a writing tool.

1. Studio Basics

Brushes

Pointed and chisel-edged brushes are made from natural (animal) hair or synthetic bristles (fig. 1-1); blends of natural and synthetic bristles are also available. The best-quality pointed brushes are all natural sable, whereas synthetic bristles (white or dyed brown) are "snappier" and allow more control for edged-brush lettering. Avoid so called camel-hair (actually sheep, goat, squirrel, or other hair) and ox-hair brushes, which usually are too soft and floppy. Hog-bristle brushes are too stiff and coarse for brush lettering.

You may want to designate particular brushes for use with certain media. An expensive sable brush will

Chisel-edged Brushes

Chisel-edged (or edged) brushes are also referred to as flat brushes or square-cut brushes. Several kinds are suitable for brush lettering (fig. 1-2). The one-stroke lettering brush is a sign-painter's tool (also sold in art stores) that has relatively long bristles; it has terrific snap, readily performs "brush maneuvers" (strokes and actions that a rigid pen or short-bristled brush cannot do as well), and carries a good load of paint. The flat brush (a specific kind of watercolor brush) has somewhat shorter bristles; the aquarelle is a watercolor brush with a fine chisel edge and a

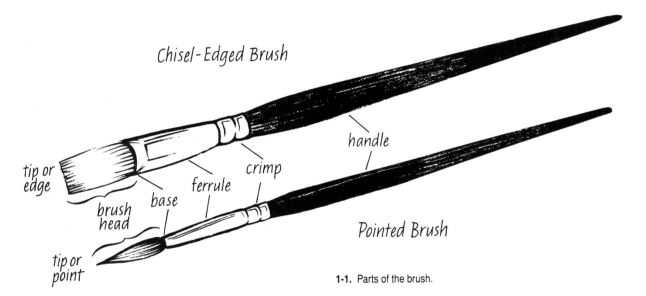

1-1. Parts of the brush.

have a longer life if it is used only with watercolor and gouache. You might reserve specific synthetic brushes for use with inks and acrylics (such as fabric paints), which are harder on brushes.

Pointed brushes are used most often for script-style writing. Chisel-edged brushes are appropriate for roman-based alphabets—for calligraphic styles that can be written with an edged pen—and for large writing. Either kind of brush is suitable for playful or experimental writing.

beveled handle (used for scraping). The watercolor bright has very short bristles; it is rigid and can be handled like a pen but does not have much snap or carry much paint. Sign painters also use showcard brushes (usually sable) and quill brushes (originally made from hairs held together in a bird's quill). These brushes have a round ferrule that permits easy twirling between the fingers, and the hairs can be paletted into a chisel edge (see "Starting Out" in chapter 2).

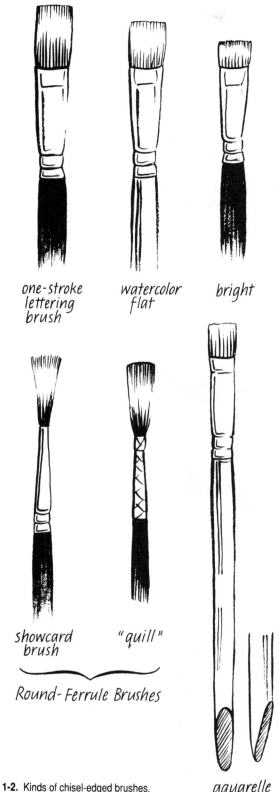

one-stroke
lettering
brush

watercolor
flat

bright

showcard
brush

"quill"

Round-Ferrule Brushes

aquarelle

1-2. Kinds of chisel-edged brushes.

You will find other kinds of edged brushes; those shown here have worked best for us. Some flat brushes that are labeled as acrylics brushes in art stores may also work for lettering; often, however, the edge is too thick and the handle too long (it can be chopped off to make a better writing tool).

Watercolor brushes and showcard brushes are sized by number (8, 10, 12, and so on); one-stroke lettering brushes are sized by width measurement: ⅛ inch, ¼ inch, ½ inch, 1 inch, and the like. Writing with a long-haired ⅛-inch brush demands control and expertise; at small sizes try a bright brush or a pen instead. Another option is to trim down the hairs at the ferrule with a sharp cutting blade to make a smaller brush head but maintain the larger handle and ferrule. (Do *not* cut the tips of the remaining hairs, however, for it is the tips that maintain the brush's razor edge and carry and spread the paint.) Also use this method to trim flyaway hairs (fig. 1-3).

Choosing an Edged Brush After deciding the kind and size of brush you want, examine and test the brush before you purchase it. Hold it to determine its weight, balance, and handle thickness; is it comfortable in your hand? Be sure the metal ferrule is tightly attached to the handle. Many brushes are stiffened with starch to prevent damage in shipping. Remove the starch by repeatedly swishing the brush in a jar of water and bending the hairs gently; if your art store does not have test water available, ask for it.

Look at the brush closely to be sure that the hairs are even across the tip. Be sure the brush does not have many wispy flyaway hairs or loose hairs. The

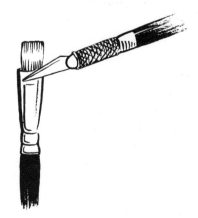

1-3. Trimming to decrease width and to eliminate flyaway hairs.

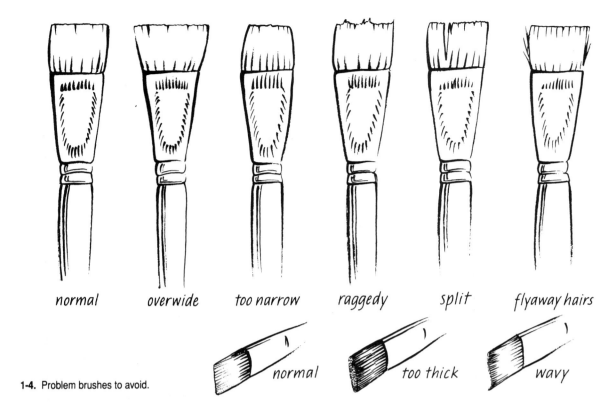

normal overwide too narrow raggedy split flyaway hairs

normal too thick wavy

1-4. Problem brushes to avoid.

brush hairs should not splay out to make a brush that is too wide or pull together to make a narrow writing edge. Watch out for splits that appear when the brush is wet, though you can often compensate for a split by paletting the brush (fig. 1-4).

The edge of the brush should be straight, not wavy or crimped at the end. For crisp lettering, you will want a brush that tapers at the tip to a fine chisel edge; a thick edge will not produce sharp strokes and fine hairlines.

Test the spring or snap of the brush, preferably wet, against the back of your hand or on a test paper; when you release pressure, the brush should spring easily back to its original, straight shape. Wet the brush again and give it one sharp shake; it should still hold its shape fairly well.

Pointed Brushes

Pointed brushes, also called rounds, are made from natural hair, synthetic bristles, or a mixture. Natural sable brushes make an excellent writing tool. Kolin-

sky sable is the finest (and most expensive) hair and has a natural taper that pulls the brush to a fine point; red sable (which is actually weasel hair) is also good. Oriental brushes use a wide variety of animal hairs (including wolf, weasel, deer, horse, and goat), and you must test their spring and ability to hold a point. Many synthetic brushes and sable-synthetic blends are well made and suitable for lettering; they are much cheaper (fig. 1-5).

Watercolor rounds, either sable or synthetic, are usually better for writing than are synthetic brushes made for acrylics, which are fatter, stiffer, and long-handled. A script brush has longer hair than a round; it can be an excellent writing tool, although it requires a more delicate touch. Oriental brushes are extremely varied in the type of hair used and the shape of the brush; some brushes have an outside ring of shorter, soft belly hairs that hold a lot of ink or water and a core of long, stiffer hairs that taper to form a fine writing tip. Handles made of lightweight bamboo give these brushes a different feel.

Some watercolor brushes come in portable versions with a removable handle or a retractable tip;

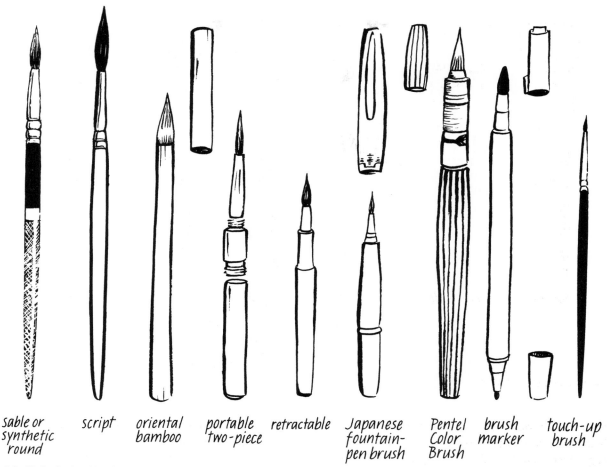

sable or
synthetic
round

script

oriental
bamboo

portable
two-piece

retractable

Japanese
fountain-
pen brush

Pentel
Color
Brush

brush
marker

touch-up
brush

1-5. Kinds of pointed brushes.

these are convenient for travel and provide a means for protecting the tip. Japanese fountain-pen brushes have a cap and use ink cartridges. The Color Brush by Pentel has been very popular; it has a very springy synthetic tip and is filled by a large ink cartridge that constitutes the handle. These brushes are no longer being imported into the United States from Japan, but they are still available through at least one mail-order calligraphy supplier and in Canada.

Brush markers are not really brushes with hairs or fibers but flexible markers made in the shape of a pointed brush. The tips are made of either a spongy or feltlike material; they respond to pressure and give some of the look and feel of brush writing. They are inexpensive and are good for layout and other quick work (the colors are made from dyes, not pigments, and may not be lightfast).

Pointed brushes range in size from very small to very large: usually 000 (triple aught), 00, 0, 1, 2, 3, 4,

5, 6, 8, 10, 12, 14, 16, 20, 24. The small brushes are good for touching up (see "Brush for Reproduction" in chapter 6), but they also can produce very delicate writing. The very large brushes are good for demonstrating or for posters or banners. Brushes ranging from sizes 0 through 5 will suit most purposes, however. Remember that with a pointed brush, you adjust your pressure to obtain different stroke weights (see chapters 4 and 5)—you do not need a different brush to make larger or smaller letters. Be aware that sizes vary somewhat among manufacturers.

Choosing a Pointed Brush Remove any packing starch with water, and test the brush for springiness against the back of your hand. Load the brush with water, and give it one sharp shake; if it points nicely, it will probably continue to point up as you write. Avoid any crimping at the tip and flyaway hairs at the base. Be sure the ferrule fits the handle tightly, and

choose a brush whose weight and balance feel comfortable in your hand. One good brush can make a wide range of letter sizes and is preferable to several mediocre brushes (fig. 1-6).

Caring for Your Brushes

If you find your brush has one errant long hair at the tip that interferes with your writing, you may want to trim it, cautiously. Do not cut it off with a scissors. Use a very sharp blade (an X-Acto knife or razor blade) and a magnifying glass on a hard surface to cut back the hair. An errant hair on a sable brush can be burned off with a flame: dip the brush in water; the one hair sticking out will dry first, so only it will burn as the tip passes through the flame. This will only work on natural hair brushes. A wispy hair that jumps out to the side can be snipped at the ferrule with a small pointed scissors.

A well-maintained brush will last a long time, and cleaning the brush is an important aspect of care. While working, swish the brush frequently in water. Also use a brush rest to prop the bristles up off the table surface. Do not let the brush soak in water, which may bend the bristles and can loosen the glue (you might ignore this rule if you are using acrylics—letting your brush sit in water during your working session may be a better option than risking acrylic paint drying in the brush hairs).

When you are finished working, wash the brush thoroughly. Cup your hand under a stream of cool or warm (not hot) tap water, and press the brush in small circles until the water runs clear (fig. 1-7). Pause to put some mild detergent in the cup of your hand, and work the detergent into the bristles of your brush. Use your fingers to massage detergent into the ferrule where paint or ink tends to collect and dry (take a preventive step by not dipping your brush into ink or paint above the ferrule). Rinse again with water and repeat this action until you have removed as much paint as possible from the brush. Shake out excess water, squeeze gently with a tissue or paper towel, and carefully reshape the brush with your fingers. *Never point a brush with your mouth.* Many pigments are toxic or carcinogenic, and you can ingest them in this way.

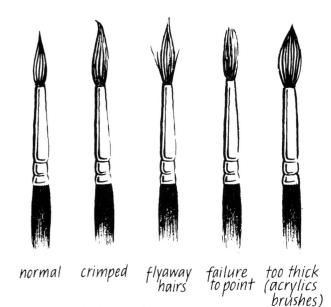

normal crimped flyaway hairs failure to point too thick (acrylics brushes)

1-6. Problem brushes to avoid.

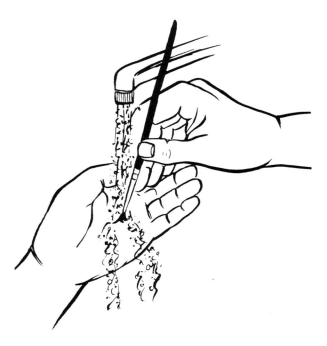

1-7. Washing out the brush.

Let the brush dry thoroughly in a horizontal position, keeping the bristles from touching any surface (you can let them extend over the edge of a counter top). Or let the brush hang downward to dry; you can make a convenient drying rack with a sponge (fig. 1-8). You can also suspend your brushes from a coil. Always let brushes air dry—never use heat. When they are dry, store them brush end up in jars or other containers, or place them in your brush carrier.

Cloth or reed brush carriers are handy for traveling (fig. 1-9). If you must pack up your brushes before they are dry, a carrier will help protect the tips. Otherwise, construct some other protective device for the bristles: a piece of matboard to which your brushes can be attached with tape or rubber bands will work. Or roll some cardboard around the brush head. Restoring the original shape to a brush that has dried pressed against something with its bristles bent is difficult; repeated washing and "coaxing" the brush with soap will help.

Brushes are damaged when they soak in water, are stored damp, are left with ink and paint caked at the base and in the ferrule (the hairs or bristles will eventually splay out), are used with harsh media (inks, acrylics, and the like), are washed in hot water, are dried with heat, or are not cleaned thoroughly. If you write frequently on rough or heavily sized surfaces, your brushes may wear down quickly. Even with the best care, brushes will show wear over time, and you will eventually have to replace them.

dry sponge with slits or holes, affixed to underside of drafting table

1-8. Dry brushes horizontal or pointing downward.

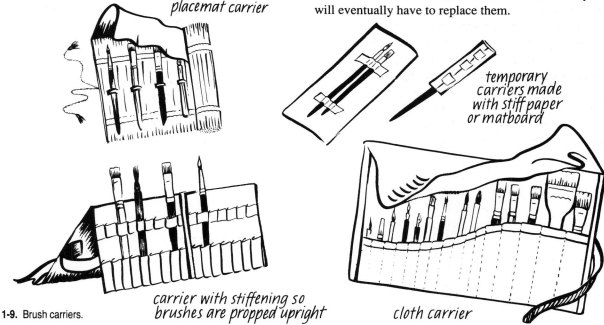

placemat carrier

temporary carriers made with stiff paper or matboard

carrier with stiffening so brushes are propped upright

cloth carrier

1-9. Brush carriers.

Studio Equipment and Supplies

Set up your studio or workspace so that you can work with optimal efficiency and minimal stress or tension. How you arrange the furniture, what kind of chair you use, where you place frequently used equipment, and how you focus the lighting are critical choices in creating a pleasing space and reducing potential strain and distractions.

Work Area

Worktable Some graphic artists prefer standing, while others like to work sitting, but it is important to have either option, to give yourself some flexibility physically and to accommodate particular jobs. Consequently, drafting tables that can be adjusted for slope and height are best. A slight slope of the table surface allows you to see your work all in one plane and reduces the need to bend over the work. The larger the piece, the more slope you need.

For large signs, the table surface may need to be almost vertical. Or you could work on a wall surface, if your paint is quite dry and does not drip; a stepladder can even become an improvised easel. A long worktable, such as a cafeteria table or dining room table with leaves, may be needed for very large signs or banners; sign shops use banner easels that can be set at any slope.

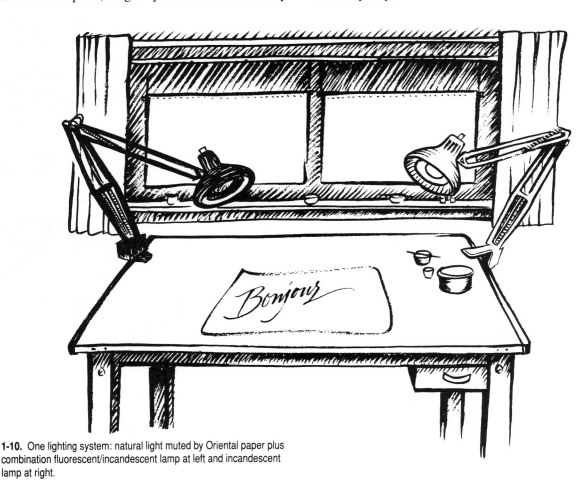

1-10. One lighting system: natural light muted by Oriental paper plus combination fluorescent/incandescent lamp at left and incandescent lamp at right.

Your drafting table or drafting board should have straight, perpendicular edges or even a metal edge to set a T square against. The table may be wood or some kind of laminate and can be protected with a self-healing plastic on which you can also cut. You can tape large sheets of paper to your drafting table to make a writing cushion, a disposable blotter for messy jobs, and possibly a notepad. Some people like a separate cutting table for cutting down large sheets of paper, matboard, or illustration board and for use as a drying surface. Be sure it is at the correct height for working while you are standing, to avoid neck and back strain. Another table might be a desk, for correspondence and billing.

Seating A good chair is a wise investment. An adjustable drafting stool or office chair is ideal: it allows you to sit with your arms at a comfortable level for working, with your back supported and relaxed and with enough flexibility to move freely and comfortably, especially for larger work. Height adjustment, either manual or by a pneumatic lever, prevents your having to hunch over, and a footrest helps keep your back aligned. A chair on wheels extends your reach so that you can to get things without getting up. Lower- and middle-back support can affect back and neck comfort when you are sitting at a drafting table; if necessary, consult a physical therapist to help design ideal back support for your situation.

Lighting A source of natural light is excellent for daytime work, especially if the light is diffuse and even, as from a skylight or a north-facing window. But if the sunlight is too bright or glaring at certain times, you will need miniblinds (adjustable to varying conditions), shades, or curtains. Another option is to hang sheets of translucent paper over all or part of the window.

Swing-arm lamps that illuminate your writing area can be pointed directly where you are working; one on each side will cancel out cast shadows. A good double light source is a combination fluorescent/incandescent lamp, which approximates daylight, on the side opposite your writing hand and a regular incandescent lamp on the other side (fig. 1-10). An additional overhead light further helps to diffuse shadows.

Storage and Containers

Brush Storage Keep your brushes, your ink or gouache (or other medium), and your water near at hand. If you have the room, keep them off the drafting table and on a low storage table (called a *taboret*) on your writing-hand side. This arrangement lets you adjust your writing table more easily and helps prevent spills. Most brush handles are round, so you will need a brush rest or notched water bowl to keep them from rolling off the table. You can buy wooden or aluminum brush rests, water containers with a coil rack, or water bins with brush holes around the edge, or you can use something simple, such as a chopstick holder (fig. 1-11).

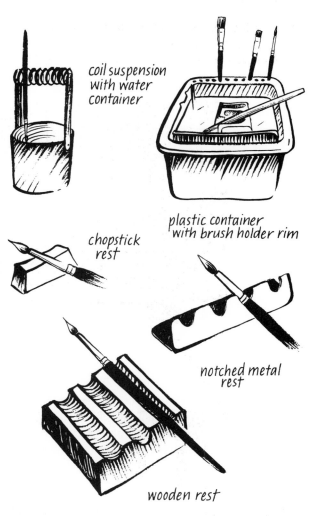

coil suspension with water container

plastic container with brush holder rim

chopstick rest

notched metal rest

wooden rest

1-11. Some brush rests.

hanging container

1-12. Storing brushes.

When not in use, brushes can be stored upright on your taboret or on nearby shelving in pottery bowls, vases, mugs, cans, or jars. For convenience, sort them into categories, such as small pointed brushes, large pointed brushes, edged brushes, Oriental brushes, unusual brushes, "bad" brushes, favorite brushes, brush markers. A rolled reed mat or a traveling brush holder also works for storage and will keep brushes dust free and protected (fig. 1-12).

Water Containers You will need water available at your worktable for rinsing the brushes immediately. Lotus bowls from Oriental import stores, fluted jelly dishes, deep ashtrays, and pottery bowls with indents on the rim make good water containers and also serve as brush rests. Almost any plastic, glass, or ceramic container will do, but clear or light-colored ones are preferable so that you can see when the rinse water is dirty. (Rubbermaid makes clear plastic containers in various sizes with a protruding rim that is convenient for handling). For large jobs involving many colors, which require frequent rinsing of your brush, you might use several small bowls—one for each main color, or at least one for warm colors and one for cool colors—along with a dump bucket and fresh water source such as a plastic milk container, to cut down on trips to the sink. Reconstitute dry paint by adding clean water from your source with a mixing brush, eyedropper, or pipette, or use a small spray bottle (fig.1-13).

Paint Containers and Palettes Pan watercolors and gouaches often come in metal or plastic boxes that have mixing areas. But if you are using tube paints, you will need a place to mix paint with water and to mix colors. Palettes with small depressions (wells) are useful for mixing small amounts; flat palettes (or dishes) will work for freer, as-you-go paint mixing (see also the discussion of media later in this chapter). Some palettes have covers for longer storage, and some fold up and are very light, for traveling (fig. 1-14). You may want one palette for gouache, one for watercolor, or several palettes for certain color groups (warm colors and cool colors, for instance). Improvise with miniature ice cube trays,

clear plastic container with extended rim

small spritzer bottle

lotus bowl

pottery bowl with indents

1-13. Water containers.

muffin tins, Styrofoam egg cartons, or, for larger amounts of paint, small microwave dishes, little airline dishes, sake cups, shot glasses, dental cups, or fast-food plastic ketchup cups. Narrow-bottomed mixing pots prevent quick evaporation, but wide containers do not tip over as easily. Japanese sumi colors come in reusable shallow ceramic dishes that can be stacked, one covering another.

Paper Storage Your storage of paper will depend on the space you have available and on the size of the paper (fig. 1-15). Inexpensive copier bond or computer paper, small pads of marker paper or newsprint, scrap paper, bristol-board pads, and tracing paper are used often and can be kept close at hand on small shelves or in trays. Larger paper, especially expensive paper, can be stored in closed portfolios, flat file drawers or map drawers, narrow vertical bins, or large sturdy tubes (you will need to unroll paper well before writing to allow it to relax). Cabinetmakers, framers, and art-supply stores regularly throw out large reinforced cardboard boxes that can be used to store paper. Another idea is to hang paper in a closet from rust-proof clips. Protect paper from damp or humid

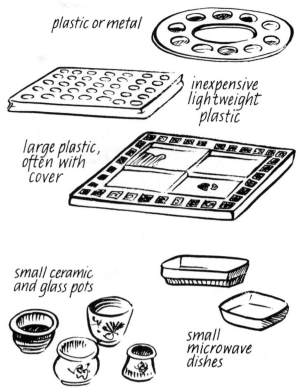

plastic or metal

inexpensive lightweight plastic

large plastic, often with cover

small ceramic and glass pots

small microwave dishes

1-14. Palettes and paint pots.

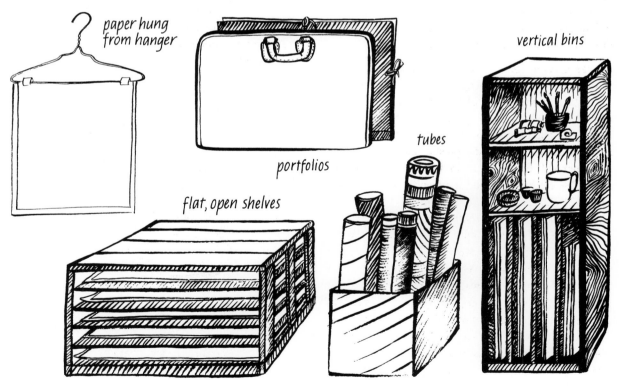

paper hung from hanger

portfolios

vertical bins

tubes

flat, open shelves

1-15. Storing paper.

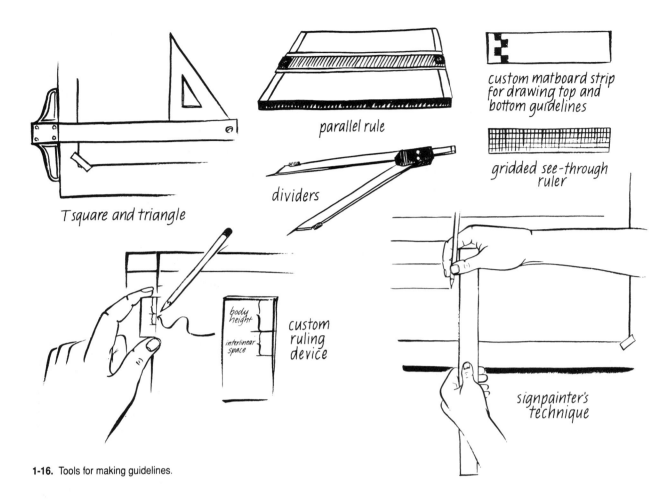

T square and triangle

parallel rule

custom matboard strip for drawing top and bottom guidelines

gridded see-through ruler

dividers

body height

interlinear space

custom ruling device

signpainter's technique

1-16. Tools for making guidelines.

conditions, which can cause mildew, and from direct sunlight, and watch out for silverfish. Remember to hold paper by its edges, with the weight hanging down, to avoid bruising.

Files, Notebooks, and Visuals Business files and reference material relevant to your work require careful consideration in studio organization. Your "hottest" files or work-in-progress can be stored in an open file near your table; finished work or less pertinent files can be kept in a closed file cabinet. If you keep reference material or sources of inspiration in notebooks or sketchbooks, consider putting a small bookshelf near your workspace. Use a bulletin board for items that tend to get lost, projects you need to critique or contemplate, and inspirational words, art, or calligraphy; a few yards of cloth on one wall can also meet these needs. Stores that specialize in organization and storage products will offer you many other ideas.

Drafting Equipment When you draw guidelines for lettering or put margins on your paper, you are using drafting equipment; these tools, shown in figure 1-16, are also needed to do paste-up for reproduction (see "Brush for Reproduction" in chapter 6). A T square that fits tight against the edge of the drafting table or board enables you to draw parallel lines—a good metal T square is an excellent investment and doubles as a straightedge for cutting with a blade. Alternatives to the manual T square are the parallel rule and the drafting arm, both of which attach to the table. For quick and easy lines for small-scale writing, you can use a gridded see-through plastic ruler. A triangle set along the edge of the T square will allow you to draw perpendicular lines for margins or columns (use a separate ruler for measuring).

You can transfer measurements, compare spacing, and achieve uniform spacing between guidelines with double-pointed compasses called dividers. To draw

repeated guidelines of the same width, try cutting a strip of matboard to size and using it as a template. If the letters' body height and the interline space (leading) are different, you can make a custom ruler on a strip of paper, marking the distances at the edge and placing the guide along the margin of your paper.

A sign-painters' technique is to use a table edge to make quick guidelines. Align your paper with the edge. Hold a ruler or straightedge with one hand and run your knuckle along the table edge, keeping the ruler at a 90-degree angle to the table edge. Hold your pencil and the other end of the ruler in your other hand (fig. 1-16). When working with the brush, you often will not need ruled guidelines at all, or you can get away with a few light pencil lines at wide intervals to help keep the letters generally straight across the page.

Other drafting equipment includes a nonreproducing blue pencil or pen (the marks from which will not be picked up by a photocopier or printer's camera), a technical pen, an X-Acto knife and no. 11 blades, white artist's tape and nongloss transparent tape, white correction fluid, and some means to attach reproduction copy to the base paper or board (spray glue, rubber cement, dry adhesive, or a hand waxer— see "Brush for Reproduction" in chapter 6).

Other Supplies To remove excess paint and water from brushes and for general cleanup, have a supply of clean soft rags (cloth diapers or old T-shirts are good), a roll of paper towels (extra strength can be dried and reused), a box of tissues, and/or some sponges. (Small, moistened sponges in a little tray with a bit of detergent on them are great for washing out brushes as soon as you use them.)

Tape dispensers for a variety of tapes are very helpful; the heavier ones allow you to pull off a piece of tape with one hand (fig. 1-17). Aside from white artist's tape and nongloss transparent tape for paste-up, you may also want masking tape and packaging tape close at hand. Transparent removable tape has a light tack and is useful for repositioning; it will not damage paper (white artist's tape is tackier but also repositionable). Some dispensers hold several rolls of tape; others can be attached to your drafting table with wood screws.

Several kinds of erasers are handy, including soft artgum, soft plastic, and kneadable charcoal erasers.

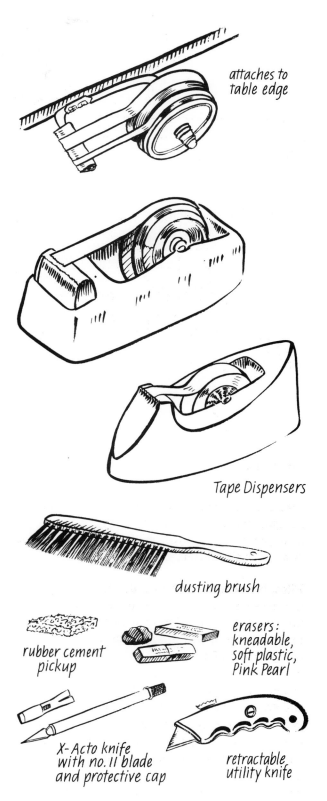

attaches to table edge

Tape Dispensers

dusting brush

rubber cement pickup

erasers: kneadable, soft plastic, Pink Pearl

X-Acto knife with no. 11 blade and protective cap

retractable utility knife

1-17. Miscellaneous studio tools.

A rubber cement pickup is used primarily for lifting off excess rubber cement but also works to pick up almost any sticky stuff. Rubber cement thinner also removes most glues; use it sparingly, with a Q-tip. It is extremely volatile and carcinogenic—be sure to store it properly, and do not get it on your bare skin.) Erasing templates help to confine the damage from erasing. A soft dusting brush for sweeping away eraser crumbs can be found at most art-supply and drafting-supply stores. Have small matboard scraps on hand for paletting your brush. A tabletop paper cutter is very useful, or you can use an X-Acto knife or utility knife on a self-healing cutting board (fig. 1-18).

tabletop
paper cutter

self-healing cutting board

1-18. Cutting equipment.

Additional Lightweight Equipment A small timer can be useful for budgeting your time, for keeping track of jobs for which you charge an hourly rate, or simply as an antiprocrastination device that keeps you focused on your work. An answering machine lets you call back when you are not in midstroke. If you talk on the phone frequently, a handset rest or a phone headset attachment can save you from neck problems and back discomfort. Some artists consider a radio or tape/CD sound system a necessity. It allows you to control your audio environment and cut out minor background noise.

Many lettering artists believe that a light box for tracing, like those shown in figure 1-19, is essential for working over a rough sketch, for making changes to type or lettering, and for seeing guidelines through heavier paper. Commercial light boxes and light tables can be purchased, or you can improvise one using a piece of Plexiglas propped on a stand or table easel with a small fluorescent fixture (undercabinet style) for back lighting (do not use incandescent bulbs—they are too hot).

Heavy Equipment Although not essential, certain pieces of office equipment are very useful and make a home studio complete. Tabletop copiers with zoom lenses can enlarge or reduce your work for immediate adjustments in your layout; some copier images are good enough for reproduction. Fax machines allow you to transmit and receive visual directions and roughs quickly and inexpensively. A home computer allows you to do basic graphics, layout, and typesetting in conjunction with hand lettering. A scanner

commercial light box

sloped light table with Plexiglas
and fluorescent light

1-19. Light boxes.

(hand models are available) enables you to input your hand lettering for cleanup or alteration on the screen. Sophisticated programs make it possible to design typefaces.

Writing Surfaces

Paper

Every artist prefers particular writing surfaces. Many excellent writing papers are available, and calligraphers can also experiment with papers used in other arts, such as watercolor painting, printmaking, Oriental brush painting, and bookbinding. No one paper surface is absolutely correct or suits every purpose. Look at paper where you buy your supplies; if you like the look and feel of something, give it a try. You will soon have your own favorites. In this section we offer recommendations based on what has worked for us.

Texture Art and printing papers come in a wide variety of textures. The more *tooth* (physical roughness or drag) the paper has, the more texture your lettering will have (fig. 1-20). Highly finished (calendered) paper and clay-coated paper are slippery, making the weight (thickness) of the strokes hard to control. Inexpensive rough newsprint, which has more tooth, is a very pleasant surface for practice and rough drafts. A rough watercolor paper may have so much tooth that it produces very textured letters unless you water down the paint and write slowly.

Papers that have unusual textures—fibers that stick up, bits of leaf and organic matter, or embossing—will work for brush writing because the brush glides over the surface and will not snag as a metal pen does (fig. 1-21). Sometimes the texture of a paper is more prominent on one side than on the other.

Papers with a *laid* surface have a ribbed pattern (originally the mark of all papers formed on a mold). The surface of vellum is quite uniform but still has some tooth; *plate* surface is very smooth. *Cold press* paper is formed by pressing the pulp against a felt surface to squeeze out water during manufacture; the rough felt surface is imprinted in the paper. *Hot press* paper is pressed between metal rollers one or more times; this process produces a smooth surface.

Color Commercial and fine-art papers come in a broad range of colors. If you are working for reproduction, colored papers can be very effective, though you may have to use an opaque paint, such as gouache, to get good coverage. Papers that are colored with dyes are not lightfast—the paper will lose color when exposed to sunlight over time. Some handmade papers are colored by the addition of pigment, rather than dye, to the pulp during manufacture,

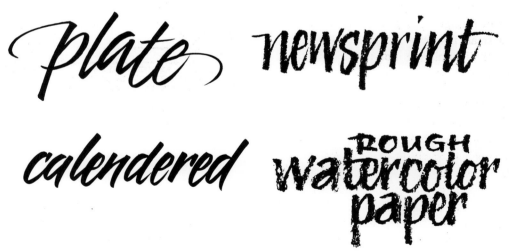

1-20. Different paper surfaces give different textures to the writing.

1-21. Brush writing on papers with very irregular surfaces.

1-22. Gouache (dry) and ink (wet) on unsized paper.

1-23. Copier bond: wet to dry gouache.

and these papers may be more lightfast. To test the permanence of color in any paper, tape a piece of it in a window that receives direct sunlight. Cover half the paper with another sheet (or keep another piece of the same paper filed away), and compare the two samples after several weeks.

Sizing Another consideration in choosing paper is whether or not it has been sized. Sizing is a dilute adhesive (such as gelatin, starch, animal glue, or resin) applied to the surface of a paper or mixed with the pulp before the sheet is made to make it less absorbent.

On unsized, or *waterleaf*, papers such as most Japanese papers, the strokes will spread or bleed if you write with ink or watery paint. With the brush, simply using a drier medium, such as a thick gouache mixture, may give satisfactory results (fig. 1-22). Very heavily sized paper may actually resist the paint or ink—try adding a drop of white glue or detergent to the mix. Some sizes are acidic. When you are concerned about the longevity of the paper you choose, make sure its pH is neutral: check with your supplier or with a manufacturer's representative.

Permanence When you work for reproduction, the visual effect of your art is usually paramount; how long the paper lasts is not a primary consideration. Inexpensive newsprint may give you the effect you want; that it may yellow and crumble in a year or two because the paper is highly acidic is not of great concern. Discoloration and brittleness are the result of weakening or shortening of the fibers in a paper caused by the presence of lignin (found in untreated wood pulp), acid, bleach, trace minerals, dyes, and some sizes. A combination of rag content, pH level (above 7 is alkaline, below 7 is acidic), and sizing determine the paper's permanence.

For artwork that is one-of-a-kind, such as a manuscript book or calligraphic piece that is to be framed, the paper you use should be of archival quality—that is, free of acid and other elements that cause paper to deteriorate—so that it will retain its desired characteristics indefinitely.

Rag papers, or those with nearly pure cellulose fibers, such as raw cotton, linen, hemp, or flax, are usually superior papers. Buffered papers, specially treated with calcium carbonate to confer a slightly alkaline pH, are quite permanent.

Naturally, archival papers are expensive because of the care it takes to produce them. But if you want your work to endure, use archival-quality paper. All other materials that come into contact with the paper—mats, frames, backing or binding boards, adhesives—must also be of archival quality.

Papers for Practice and Reproduction Regular bond or copier paper works well for rough drafts, warm-ups, or practice, and for creating art for reproduction. If you are using ink or a watercolor that is heavily diluted with water, however, these papers may buckle; switch to a a heavier-weight drawing paper. Pads or individual sheets that are at least 11 by 17 inches are recommended, because the scale of brush writing tends to be large. Other possibilities include the long continuous rolls of butcher or banner paper, blue-line graph paper, newsprint, and computer paper.

Many bond papers enable you to produce legible but textured letters that, when reproduced, can look the same as lettering done on an expensive handmade paper. The dryness or wetness of the paint combined with the roughness of the paper surface and the speed at which you write determine the texture of the stroke (fig. 1-23). A good all-around paper with tooth for more textured strokes is a 25-percent cotton bond, a commercial paper that you can purchase by the ream (five hundred sheets) (fig. 1-24). Charcoal or pastel paper also enables you to create texture in your strokes, but you will be able to see the laid pattern of this paper in the stroke. Charcoal and other cover-weight papers come in a range of colors and in black (fig. 1-25). Inexpensive papers, such as oatmeal paper (a high-acid, wood-pulp paper) and certain Oriental papers can give interesting effects (fig. 1-26). When you want to produce letter strokes with smooth edges, write on a slick or smooth-surfaced paper, such as a clay-coated sheet, translucent drafting vellum, or frosted Mylar.

Paper for Original Artwork Color, texture, weight, and deckles (ragged edges, as shown in fig. 1-27) are critical considerations when choosing paper for one-of-a-kind artwork that will be viewed directly and handled. The choice of papers, both handmade and manufactured, is vast, and you can use a much wider range of papers with the brush than with the pen—papers made from mulberry bark, Oriental

1-24. Twenty-five percent cotton bond: wet and dry gouache.

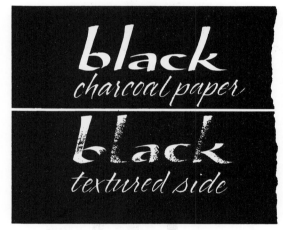

1-25. Black gouache on white charcoal paper; white gouache on both sides of black charcoal paper.

1-26. Oatmeal, an inexpensive, high-acid wood-pulp paper.

1-27. Deckle edge on Rives BFK paper.

1-28. A wide range of papers can be used for original artwork.

papers made from bast and grass plants, and rough handmade papers, to name a few (fig. 1-28). You will still need to consider texture (tooth), absorbency (sizing), cost, and permanence with each kind of paper you try.

Other papers to consider for original art are watercolor papers, printmaking papers (they are more absorbent), novelty papers (such as papyrus and wood veneer), pastel and charcoal papers, fine-art papers, and mold-made papers (fig. 1-29). Watercolor papers are categorized as hot press (smooth), cold press (medium texture), or rough, and are sold in 90-, 140-, and 300-pound standard weights (paper weight is determined by how much a ream of that paper cut to a standard size weighs).

Tearing paper, instead of cutting it, gives a more natural edge, especially if other edges have a deckle. To guide your tearing, you can score the paper by pressing a line with a blunt, hard tool (such as a bone folder or the back of a table knife) or fold the paper by matching corners. Or you can use a straightedge: pull the paper toward you against a ruler or T square held perpendicular to the bottom edge of the paper. You can also make a wet tear: use an eyedropper or brush to apply a thin line of water where the paper is to be torn, let it soak in, and then gently pull apart. You will get a natural-looking edge, especially with very fibrous paper (fig. 1-30).

1-29. Some other possible paper choices for original artwork.

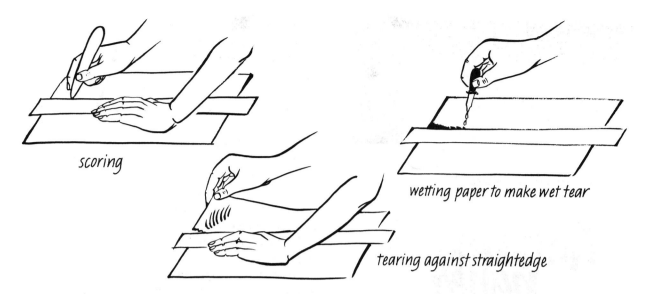

scoring

wetting paper to make wet tear

tearing against straightedge

1-30. Tearing paper to make a softer edge.

Boards You can use a brush to letter on any paper-covered surface, including matboard and a variety of illustration boards (fig. 1-31). Large chisel-edged brushes and sign-painters' brushes are good tools for making signs or posters on matboard or illustration board, especially those with some tooth. Avoid railroad board, tagboard, and any of the less expensive colored boards, which are often very slippery, making lettering difficult.

Corrections Mistakes on paper, illustration board, or matboard can be corrected in a number of ways. You can carefully scrape off the paper fibers that have a mistake with a sharp X-Acto blade, then gently rub the corrected area with a soft kneaded or plastic eraser. An erasing shield will block off all but the critical area and protect surrounding paper. Burnish the scraped area with a hard, blunt tool such as a bone folder to smooth the fibers so you can write on them again (see also "Media," later in this chapter). Use gouache instead of ink to write in the correction: ink will bleed where the paper has been scraped. If the mistake is writing the wrong letter, first write the correct letter over the mistake, then scrape only where necessary (fig. 1-32). You can also try blotting mistakes with a clean brush, water, and a blotting tissue. Or you can cover a mistake with paint mixed to match the paper; a small pointed brush is your best tool for making such repairs.

Bristol Board
matboard
Illustration Board

1-31. Paper-covered boards.

mistahe
mistake
mistake

1-32. Correct mistakes by scraping or using paint mixed to the color of the paper.

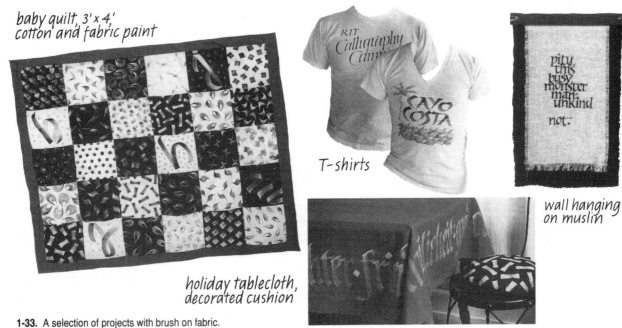

baby quilt, 3' x 4', cotton and fabric paint

T-shirts

RIT Calligraphy Camp

CAYO COSTA

pity this busy monster man. unkind

not.

wall hanging on muslin

holiday tablecloth, decorated cushion

1-33. A selection of projects with brush on fabric.

Fabric

Using alternative surfaces such as fabric—cottons, linens, silks, and even some synthetics—expands your options for artistic expression. As with paper, you will need to consider texture, absorbency, and cost when making your choice. Many large fabric outlet stores will sell you small amounts of fabric or will have remnants for sale at a discount. Fabric stores also carry fabric-marking tools and even some fabric paints. Art-

supply stores and craft stores are other sources for fabric paints.

You can use fabric for a variety of lettering projects, including unique calligraphic art pieces, banners for decoration or information, and clothing and home furnishings, such as T-shirts, curtains, or decorated yardage (fig. 1-33).

Fabric is an excellent surface for brush lettering and, once you learn a few simple techniques, it is surprisingly easy to use. You do not need to apply gesso

one two three

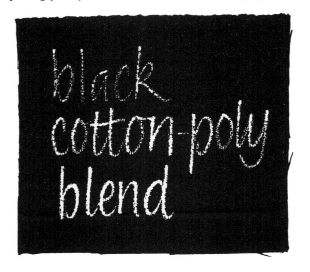

black cotton-poly blend

1-34. Double- and triple-stroking to build up paint on fabric, keeping hairlines.

or otherwise pretreat, stretch, or mount the fabric. All you need is a backing board or table space to accommodate the project.

Working on most natural-fiber fabrics such as cotton, linen, or silk is much the same as working on a highly textured paper: they have a natural resistance or drag that allows you to work slowly with a lot of freedom. For the letters to be opaque, you will often need to apply the paint in layers; fabric tends to be very forgiving of this double- and triple-stroking process (fig. 1-34). Wall hangings and banners are durable, flexible, and easily stored, and they offer many alternatives for color, texture, and presentation.

Choosing the Fabric and Medium For pieces that will not be washed, you can use any fabric that suits your purpose and can be written on (for example, silk, cotton, ultrasuede, leather, burlap, canvas, interfacing, satin lining, as shown in figure 1-35) and any medium you prefer (such as watercolor, gouache, acrylics, technical-pen ink, and brush marker).

Pieces that will be washed—clothing, pillow covers, curtains, tablecloths, for example—may need to be prewashed to remove sizing (substances applied to fabric to preserve crispness and prevent wrinkling) and to preshrink the fabric; for these items, use only permanent, washable media. Do not prewash knits,

such as T-shirts, because washing raises the nap of the fabric and makes lettering on it harder.

Natural-fiber fabrics without sizing, such as cotton, cotton knits, silk, and linen, make ideal writing surfaces. Synthetic (petroleum-based) fabrics tend to be more slippery or absorbent, though many natural/synthetic blends work well, as does rayon, which is manmade from organic fibers. Nonfusible interfacing, especially when torn, not cut, makes an interesting surface for painting and lettering, as does Tyvek, a material developed for the building industry, which is also used for making very strong envelopes and other products.

Avoid using nylon, especially rip-stop nylon, for hand lettering; it is slippery and resists coverage.

Writing Techniques Experiment first with any fabric you choose. You do not need to stretch the fabric; just iron out any wrinkles and spread it out, lightly weighting the corners, if necessary, so it will not slip around as you write. You can tape or pin the fabric to a piece of matboard, so you can rotate it as you work. Lift up the fabric after you apply the first coat of paint, to keep it from sticking to the work surface. A filmy material such as cotton batiste or china silk, especially, may require you to apply several light coats of your medium (allow drying in between) to achieve

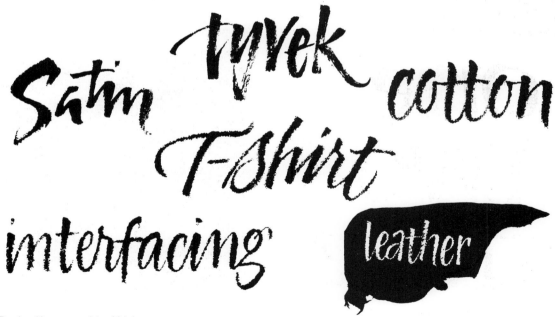

1-35. Brush writing on a variety of fabrics.

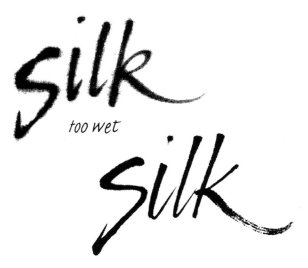

1-36. Use a drier medium for very fine fabrics.

1-37. Working diluted paint into loosely woven fabric.

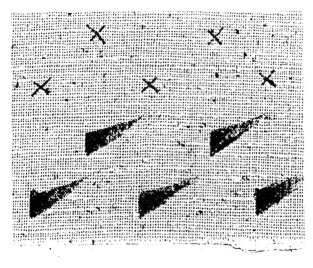

1-38. Gridding fabric with chalk or fabric marker.

coverage. You may have to use a drier medium (gouache instead of ink) on a very fine fabric to avoid bleeding (fig. 1-36). Some sturdier fabrics, on the other hand, can take more direct stroking with a heavily loaded brush. For designs that require heavy paint coverage, you might want to use fabric paints specially formulated for lightness and flexibility. A loosely woven fabric requires a diluted paint that can be worked into the weave spaces (fig. 1-37)

Designs and guidelines can be sketched with fabric-marking pens that have washable or disappearing ink, with dressmaker's chalk (found in fabric stores), or even with a basted line of thread that can later be removed. With lightweight or light-colored fabric, you can use a design underlay that you have worked out ahead of time on paper. Remember to slip the underlay out after applying the first coat of paint to prevent sticking.

Clothing You can pattern or write on fabric and then make clothing from it, or you can use ready-made clothing—shirts, blouses, T-shirts, aprons, hats, bibs, or any other garment, even cloth shoes—and letter directly on them. To decorate the material before cutting and sewing, mark a grid or pattern on the fabric and apply a simple brushstroke or mark in a repeat pattern for the amount of yardage needed (fig. 1-38). When you letter on made-up articles, it is very important to use a backing board so that the paint does not seep through to a part of the article that you do not want to mark. Cut custom backing boards for unusual spots, such as pants legs or sleeves. As the paint is drying, lift the fabric away from the backing so it does not stick.

Stenciling and Stamping When one image needs to be repeated, either to make an overall pattern or to produce multiple items with the same design, consider cutting a stencil and applying fabric paint with an extra-stiff stencil brush (fig. 1-39). Apply fabric paint or gouache to a simple design on a rubber stamp and stamp onto the fabric; stenciling or stamping can be used on premade clothing (fig. 1-40).

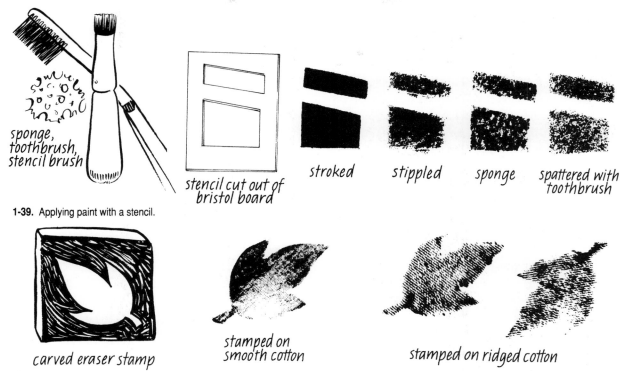

1-39. Applying paint with a stencil.

sponge, toothbrush, stencil brush

stencil cut out of bristol board

stroked stippled sponge spattered with toothbrush

carved eraser stamp

stamped on smooth cotton

stamped on ridged cotton

1-40. Stamping on fabric with rubber or eraser stamp.

Media

The brush is a versatile writing tool that works with almost any liquid or gel medium, from inks to oils, watercolor to wine. On paper surfaces, the most commonly used media are ink, watercolor, and gouache (opaque watercolor, pronounced *gwash*); on fabric surfaces, acrylics, including fabric paints, are often used. Each writing medium has its advantages and disadvantages, its particular handling characteristics, and its special results.

Ink

Ink is convenient—you can use it directly from the bottle without mixing or adding water. You can write smoothly and fluidly with ink on most papers. Many black inks produce dark, even-toned writing and are therefore reliable for work that is to be reproduced, by copier machine or by offset printing. Writing with ink on smooth or coated papers produces solid strokes with crisp edges; paper with more tooth allows you to create textured letters.

You can choose waterproof or nonwaterproof inks, as well as colored inks that are pigmented (color particles suspended in a liquid vehicle) or made from dyes (coloring agents dissolved in a liquid solution). (The latter can have very intense colors that reproduce well but often are not lightfast.) Using an eyedropper, you can make controlled mixes of ink colors that you can match later.

The watery, even consistency of bottled ink allows you to dip and write without much paletting of your brush. You can also grind your own ink from an ink stick to the exact consistency you want. Many people prefer to grind their own ink, considering the task an integral and meditative part of the writing process. To grind your own ink, deposit just a few drops of water on an ink stone, hold the ink stick upright, and move

it back and forth or in small circles against the stone until you feel the mixture thicken (fig. 1-41). Collect the ink in the depression of the stone.

Ink is harder on brushes than certain other media are because of the shellac, ammonia, and other chemicals that it may contain. You may want to reserve your very fine brushes for water-based paints. We do not recommend using ink with an edged brush, although some people like this combination: the thin consistency of the ink causes the bristles to split apart and lose their springiness while you are writing. On many papers, especially those that are not sized, ink tends to bleed or feather; because ink permeates the paper fibers, it is also harder to remove with a blade or eraser for corrections. It may feel hard to control (slippery and fast), and you cannot easily thicken it.

You have many kinds of inks to choose from. India ink for fountain pens is not waterproof but may be quite thick and creamy. Technical-pen inks are waterproof and can also work nicely. With waterproof inks, it is a good idea to have a jar or bowl of rinse water nearby: swish your brush in it periodically to prevent ink from drying around the ferrule. Chinese or Japanese sumi inks come in stick, paste, and liquid form; as a rule the quality of these inks corresponds to their price.

Lightfastness is a consideration with colored inks: pigmented inks are generally quite lightfast, whereas inks made with dyes are not. Do your own test to see how light affects the colors. On paper, paint a wide band of each ink you want to test, cover half of each sample with a sheet of paper, and then expose the samples to direct sunlight in a window (fig. 1-42). After a few weeks, compare the covered and uncovered ink marks to see if fading has occurred. If an ink fades, avoid that ink for work that will be exposed to light, but you may still use it when permanence is not required—for reproduction or for casual studies.

Whatever types or brands of ink you choose, also test them, by using them for practice work, for the qualities of blackness or color intensity, smoothness, and thickness that you desire.

Avoid dipping your brush into the ink bottle. A narrow bottle neck makes it difficult to keep the handle free of ink, and it is hard to control the depth of the brush. Instead, pour some ink into a small container such as a sake cup or a dental cup, use a dropper to put

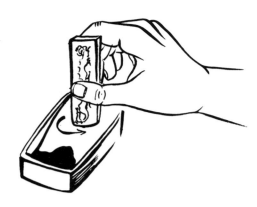

1-41. Using sumi inks.

1-42. Testing inks for lightfastness.

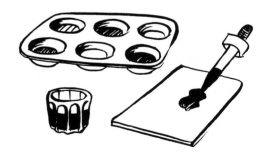

1-43. Place ink in a palette or small container, or on matboard.

ink in the wells of a plastic palette, or place a puddle of ink on a small piece of matboard (fig. 1-43). (With the last method, you can also thicken the ink by spreading it to speed evaporation.) Be especially diligent in cleaning out your brush after using ink; dried ink that accumulates around the ferrule will damage the brush, and it will fail to point.

Gouache

Gouache is an opaque watercolor medium that comes in tubes or cakes (pan gouache) (fig. 1-44). Like transparent watercolors, it is made with color pigments, and many brands carry lightfastness or permanence ratings on the containers. The better-quality (and higher-priced) gouaches mix up easily and write smoothly; unlike the thinner inks, they give "body" to the brush. Many artists prefer their even coverage, opacity, and mat finish; also, you can touch up gouache with gouache.

The paint tends to sit on the surface of the paper rather than being absorbed as ink is, which allows you to use a wider range of papers (and other materials) and makes correcting by scraping easier. Tube gouache mixes with water to any consistency, enabling you to control the texture of the strokes without changing paper (fig. 1-45). With gouache, cleanup is easy, spills are less disastrous, and well-maintained brushes will have a long life.

Some manufacturers of products for graphic designers offer small jars of finely ground white and black liquid gouache that are convenient to use. Light-colored gouache works well on a dark ground such as black paper (fig. 1-46); adding some white gouache to

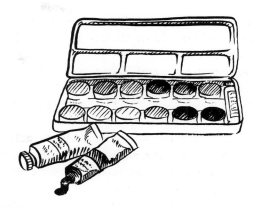

1-44. Gouache in tubes and pans.

the mix helps to "pop" the colors. Be aware that there are different whites and blacks. Zinc white is warmer (more yellow) than permanent white; permanent white is more opaque and therefore good on dark papers. Ivory black, lamp black, and jet black have different properties: jet black is cool (blue tones) and is the most opaque.

With the edged brush and gouache, you can produce a striped or rainbow effect in your strokes by loading the brush with one color and dipping one side or the corners in a different color or colors (fig. 1-47). For more blended colors, load the brush first with water. For more controlled coloring, use a pointed brush to apply the paint to your edged brush. To achieve a shaded effect, use two different values or tones of the same color. You can also mix colors on a pointed brush by loading with one color and then dipping the very tip in a second color.

Gouache does have some disadvantages. It is difficult to remix exactly the same shade of a color; the paint dries to a slightly darker shade. If the gouache is

1-45. Gouache mixed from dry to wet on the same paper.

1-46. White gouache on black paper.

1-47. Multiple colors or shading in the brushstrokes.

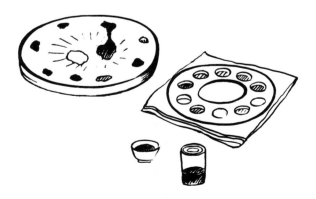

1-48. Tube gouache mixed "as you go" on flat palette; in palette with wells (stored in self-sealing plastic bag); in small containers; in film canister.

mixed to a thick consistency or if it is not of good quality, it may chip or powder. Because it is not waterproof and sits on the surface, gouache may smear if touched or moistened, and it is difficult to erase around the lettering. Mixed tube gouache that has dried usually can be reconstituted with water, but it may eventually crack, curl, or crumble (you will have no problem determining when you can no longer reuse it).

If you are using tube gouache, squeeze an ample amount into a small container (a narrow base will help keep the paint moist longer). Try not to be stingy—mix up more paint than you think you will need. Add a few drops of water at a time to obtain the desired consistency, and mix very thoroughly with a stir stick or a mixing brush. You may wish to add a little gum arabic to smooth the mix, to prevent chipping or powdering, and to improve the paint's adhesion to the paper. If you are using small amounts of paint or several colors at once, mix the gouache in a plastic palette with shallow wells. Or you can place dollops of fresh paint around a flat palette and mix colors as you go (fig. 1-48). To save gouache that has been mixed in a container, add more water and cover with plastic wrap (or use an airtight film canister for storage). A palette can be spray-wetted and put in a self-sealing plastic food-storage bag.

Spray or otherwise wet pan gouaches before you start working and allow the paints some time to soften. If you will be using several colors simultaneously, you can work up some color patches on a plastic palette so they are ready to go. The cakes of gouache usually pop out of their box so they can be rinsed for cleanup.

Mistakes can often be scraped out (carefully) with a sharp blade; then burnish the disturbed paper fibers and repaint as necessary (see also the discussion of corrections earlier in this chapter). If you need to erase pencil marks, use a bouncing motion and direct the eraser into the letter strokes to avoid smudging (fig. 1-49). If you are concerned about the gouache smearing or not adhering, you can spray the finished work lightly with an aerosol fixative (a workable fixative will let you write on top of it without disturbing the layer underneath). Be sure to test the fixative and gouache combination first on scrap paper (fixing could discolor the paint or cause it to run).

scraping with
sharp blade

1-49. Correcting and erasing.

burnishing with plastic pen cap
and paper protection

Erase with a bouncing movement
toward the letter stroke.

Watercolor

Although watercolor is basically a transparent medium, some colors have more opacity than others; colors can also be mixed with Chinese white or white gouache to increase opacity. The color will be lighter and somewhat neutralized. Watercolors come in small and large tubes and in pans and half-pans, and they are designated student grade or artists' quality (fig. 1-50). Watercolor pigments are more finely ground than those in gouache, and they work up beautifully when water is added. Dried high-quality watercolors can be reconstituted indefinitely, and a little paint goes a long way. Many manufacturers offer small boxed sets that are lightweight and very portable. Liquid watercolors in bottles are very brilliant but usually are made from dyes and are not lightfast; they are thin like inks. Japanese sumi colors are more opaque than traditional Western watercolors and come in shallow ceramic dishes; the binding agent is hide glue rather than gum arabic. Watercolors combine well with other media, such as graphite, colored pencil, or gouache.

The transparency of watercolor may or may not be desirable, depending on your intent (fig. 1-51). Transparent watercolor works best on a white surface; it does not touch up easily once dry, but you can make some changes while it is still wet. Most watercolors dry to a slightly lighter tone. Erasing nearby pencil marks is easier than with gouache, but pencil marks under the watercolor may remain visible. Certain artists' watercolors, in either tube or pan form, can be very expensive.

Tube watercolor can be squeezed onto a flat palette (or into separate palette wells) and used in its wet or dried state (spray or prewet the dried paints). With both tube and pan watercolors, you can use a great

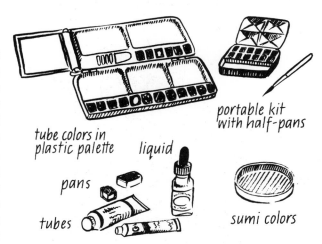
tube colors in
plastic palette

portable kit
with half-pans

liquid

pans

tubes

sumi colors

1-50. Kinds of watercolors.

1-51. Transparent and opaque watercolors.

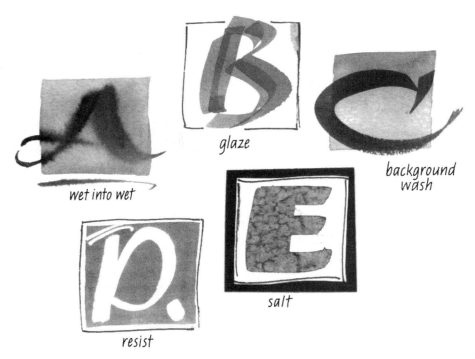

wet into wet

glaze

background wash

salt

resist

1-52. Some watercolor techniques.

variety of painting techniques (fig. 1-52); for example, working wet into wet (dabbing wet paint into a still-wet painted area) or glazing (applying another color over a dry color). Try using dry brush for texture, using wash backgrounds (applying a light, even layer of color), using resists (liquid products that block out areas or letters so the paper underneath will show through when the resist is removed), or adding salt to create texture. All of these techniques are described more thoroughly in the many books available about watercolor. To correct mistakes in watercolor, scrape with a sharp blade or use a dampened brush or sponge to lift off the color.

Fabric Paints

Fabric paints are specially formulated acrylics for use on cloth. They withstand washing, are not as stiff as regular acrylics are when dry, and usually work smoothly and evenly. Many products for topical application (as opposed to dyes) are available on the market. Fabric paints come in standard colors, fluorescents, metallics, luminescents, soft and hard markers, crayons, and squeeze tubes. Fabric paints can be thinned with water or acrylic extenders that help maintain strength.

Manufacturers have developed high-quality fabric paints that leave the fabric supple and are therefore good for covering large areas. Silk fabric paints are made to flood areas of the silk that have been blocked off with special resists or with wax, but regular fabric paint at normal thickness can be used directly on silk. Most fabric paints require that you heat-set them with a warm iron (on the reverse side of the fabric) or put them in a warm dryer to ensure bonding of the paint with the fabric surface.

Acrylics

For some applications, particularly where a durable and waterproof medium is desirable, acrylic paints may be a good choice. They can be thinned to be used transparently, or they can be used full strength, but they do not have the same flatness and opacity as gouache. See "Other Media" in chapter 6 for a discussion of acrylics as a writing medium.

2. Introduction to the Edged Brush

Starting Out

Holding and Paletting

Hold the chisel-edged brush just as you would a large metal pen, except perhaps more vertically, with the handle resting near the second knuckle of your finger. The brush must be as perpendicular to the paper as possible and thus more vertical for a flat surface than a sloped one. Such a position enables you to use the thinnest edge of the brush and keep the pressure light. Grip the brush where the ferrule joins the handle (fig. 2-1). Mix enough gouache to fill a small mixing dish or container; tube gouache is mixed to the consistency of cream. (Writing with gouache, or designers' colors, will give you distinct opaque strokes that you can compare with the alphabet model you are following. Gouache is also easy to mix, and it washes out of the brush readily.)

Immerse the brush in water, and blot or squeeze out the excess. If the brush is new, be sure the packing starch is completely washed out. Dip the brush into the gouache up to but not over the ferrule; avoid getting paint around the base of the fibers. Any excess paint will be blotted off in the paletting process.

Paletting (or beating out) the brush organizes the bristles, keeps the brush a uniform width, distributes the paint, and shapes the edge into a sharp chisel. Palette on a small piece of cardboard or matboard or even an old business card printed on uncoated stock. A surface that is very absorbent, such as paper toweling, will soak up too much paint; a slick surface, such as a plastic tray or dish, will not help you squeeze off excess paint. Lightly palette each side of the chisel brush, either by rotating the brush as you stroke in one direction or by pulling the brush back and forth across the board in each direction (fig. 2-2). A good brush should snap back into a sharp chisel as you write. Usually you will need to repalette the brush only after you have recharged it with paint, or more often if you are making strokes with many changes of direction or pressure.

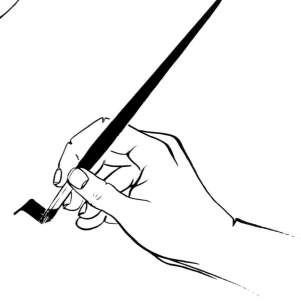

2-1. Hold the brush as you would a large metal pen.

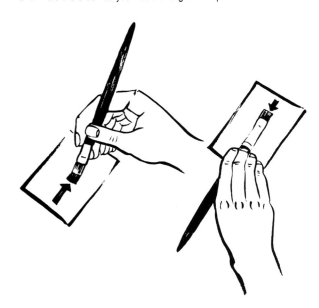

2-2. Paletting the brush on a piece of cardboard.

Making Strokes

Start making strokes on paper by pulling some diagonal strokes from lower left to upper right using the tip of the brush and very light pressure (fig. 2-3).

2-3. Diagonal strokes up on the brush edge. Keep pressure light.

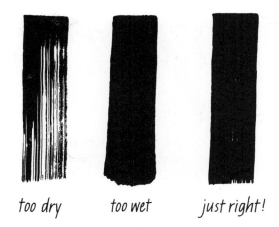

too dry *too wet* *just right!*

2-4. Different paint consistencies. Mix paint to the consistency of cream.

Remember to hold the brush perpendicular to the paper. You will find these strokes to be less crisp and straight than pen marks, but try for as few wobbles as possible. Make a few more marks to make sure your paint has the right consistency. Figure 2-4 shows strokes that are too dry and too wet. You may want a dry-brush texture eventually, but for beginning practice you need to be able to see if you are reproducing the model alphabet; for this you need a dark, solid stroke.

Experiment with pressure to produce new effects. Make a mark that reflects the natural width of the brush; for example, a ½-inch brush will make a mark approximately ½ inch wide. Now, applying gentle pressure, fan the bristles out by bearing down on them, and pull a wide stroke. Notice how rough the end of the stroke is (where you have lifted off from the paper); this mark is made by the middle of the brush bristles instead of the very tip or the chisel-edge (fig. 2-5). After this exercise, you will have to go back and palette your brush.

Your first marks may have some little wiggles; these will disappear as you develop confidence and increased speed with the tool. Try to avoid major pressure changes, however, to prevent the strokes from having large bumps (fig. 2-6).

Keep the brush clean by periodically swishing it in water and blotting excess water and paint. If the bristles become too clogged with paint at their base inside the ferrule, the brush will lose its snap and flexibility. Never leave a brush soaking in water, as the bristles may become misshapen or the glue that holds the bristles in the ferrule may deteriorate.

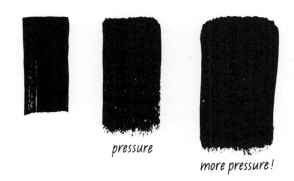

pressure

more pressure!

2-5. Make a mark to reflect the natural width of the brush; then apply pressure to fan out the brush and again make a mark.

2-6. Little wiggles are easy to eliminate with speed; avoid large changes in pressure.

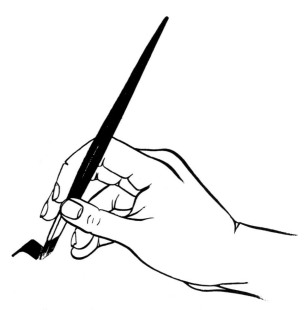

2-7. A three-finger hold with two fingers on top of the brush shaft; the heel of the hand touches the paper.

Alternative Brush Holds

Changing the position of the three fingers you use to hold the tool can increase your freedom of movement. Place two fingers on top of the shaft, opposing the thumb to them. Cock your wrist and rest the heel of your hand on the writing surface, or place just your little finger on the surface for balance. Continue to keep the brush perpendicular to the writing surface, so that you are using the very tip to produce fine, crisp strokes (fig. 2-7).

A two-finger brush hold, especially with the long-bristled one-stroke lettering brush, can give you great flexibility and maneuverability. This grip may seem precarious at first, but with practice you will have considerable control. Hold the handle of the brush perpendicular to the writing surface, perhaps resting it against the top knuckle of your index finger, and use only the thumb and forefinger to grip the ferrule lightly where it joins the handle. Your hand should not touch the paper (fig. 2-8). You can rotate the brush 360 degrees in this position, and by applying pressure, releasing, and twisting, you can fully exploit the dynamic action and snap of the brush. With this hold you can involve your fingers, wrist, arm, and shoulder in making the strokes, enabling you to produce very large letters. Moreover, your hand will not touch the wet paint (an advantage for left-handers) or deposit any oils on the paper. You can work standing, leaning slightly over the flat writing surface, or you can work vertically on a wall or at an easel. Flourishes and free strokes become very natural gestures with this method.

With either a three-finger or two-finger hold, you may wish to prop your writing hand on your opposite fist or wrist for greater control. Roll your wrist toward your body, letting this movement pull the brushstroke downward (fig. 2-9). You can also purchase acrylic or metal bridges to prop your hand for greater control in pulling long straight strokes or doing precision lettering.

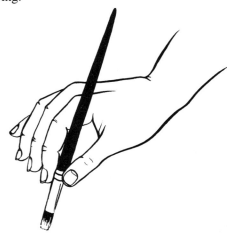

2-8. A two-finger hold, gripping the brush with just the thumb and forefinger.

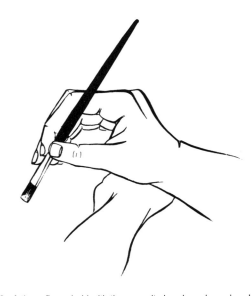

2-9. A three-finger hold with the opposite hand used as a hand rest. Roll your fist toward you as you pull down the brushstroke.

Warm-ups

You can experiment with the brush in a variety of ways to warm up. You will find that making marks and doodles on unlined paper instead of letterforms on guidelines is less confining. Concentrate on the sensation and effects of pressure changes and on an even flow of paint. Fill a page with free-form marks, straight, curved, thick, thin, and twisting strokes for which you change pressure in midstroke (fig. 2-10).

Now, on a fresh sheet, try some more disciplined marks by holding an edge angle (the relationship of the brush edge to the writing line) of forty-five degrees; make diamond shapes and vertical and curved strokes (fig. 2-11). Be sure the brush has been paletted and the pressure is even. A moment of hesitation as you set the brush to paper and again just before you lift it off the paper will keep the ends, or terminals, of the strokes crisp.

The ultimate test of pressure control is making the thinnest stroke up on the edge of the brush in a diagonal, vertical, or horizontal direction. The quality of this stroke will tell you if your pressure is light enough and if you are holding the brush perpendicular to the writing surface. You can alternate these edge "tiptoe" hairlines with a wider, edge-angle stroke for warm-up patterns (fig. 2-12).

2-10. Free marks on unlined paper; change directions often to warm up.

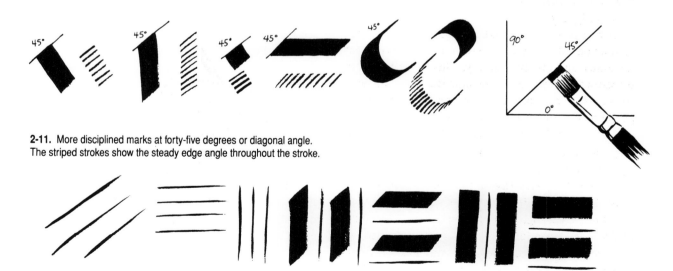

2-11. More disciplined marks at forty-five degrees or diagonal angle. The striped strokes show the steady edge angle throughout the stroke.

2-12. Hairline strokes on the edge of a paletted brush. Alternate "tiptoe" and full edge strokes.

2-13. *Left:* Diagonal zigzag pattern: release pressure on the hairlines (thins). *Right:* Right-angle or stairstep strokes: release pressure to exit on hairlines.

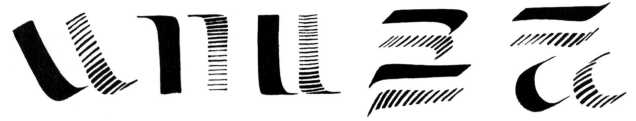

2-14. Changing pressure on various strokes. *Left to right:* Ends of diagonals, tops and bottoms of vertical strokes, entering or exiting horizontals, in the middle of curved strokes.

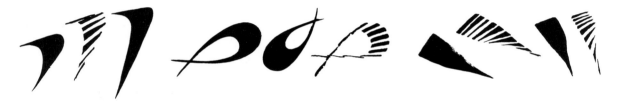

2-15. *Left:* Changing angle in a corner stroke. *Center:* Changing angle in a curved stroke (snapfish). *Right:* Tapered strokes made by changing the angle constantly; the brush actually rolls between the thumb and gripping finger.

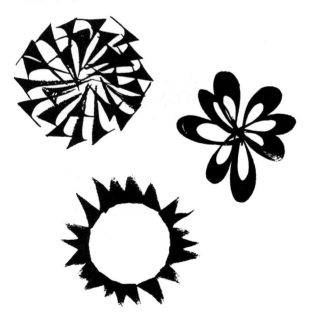

2-16. Calligraphic drawings.

Now combine a tiptoe diagonal upstroke with a full edge-angle diagonal downstroke to make a zigzag pattern; you will find that you need to lighten pressure considerably on the diagonal upstrokes. Combine thin horizontal and thick vertical strokes at right angles in a stairstep pattern; also try thick horizontals with thin verticals (fig. 2-13). These right-angle combinations are a good warm-up for making letters with serifs.

Applying and releasing pressure on the brush greatly increases the options you have to create strokes and letterforms. Some degree of pressure manipulation is involved in lettering the roman and italic alphabets presented in this book. You can make a flared stroke by using a controlled change of pressure. Starting with a diagonal stroke, slightly increase your pressure toward the end of the stroke, then release the pressure to exit. Also try increasing your pressure very slightly at the beginning and end of vertical strokes and horizontal strokes and midway in curved strokes (fig. 2-14).

You can also manipulate the brush by changing the edge angle as you make a stroke. A corner stroke with an angle change resembles the first shape shown in fig-

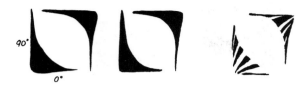

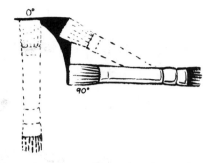

2-17. Corner stroke with angle change from 90 degrees vertical to 0 degrees horizontal and from 90 degrees horizontal to 0 degrees vertical.

ure 2-15. Changing the angle in a curved stroke and crossing the entrance and exit strokes produce a teardrop or fish shape. A tapered or triangular stroke is made by changing the angle continuously and rapidly in a twisting clockwise or counterclockwise motion. These marks can be used in calligraphic drawing, as they resemble petals, leaves, and other natural forms (fig. 2-16).

A corner stroke, like that shown in figure 2-17, is more of a challenge. It twists rapidly from zero degrees to ninety degrees or ninety degrees to zero degrees in a pivoting motion. For these warm-ups,

which require extraordinary brush manipulation, you might want to consider using a grip that allows more freedom of movement, as explained earlier in this chapter.

A good warm-up for letters is a simple calligraphic bird (fig. 2-18). You can manipulate the brush or change pressure to vary the body of the bird. Legs are formed by touching the edge of the brush to the paper or by making a slim variation of the tapered marks. These warm-ups are fun and less strict in form than letters, good for getting used to the tool and staying relaxed.

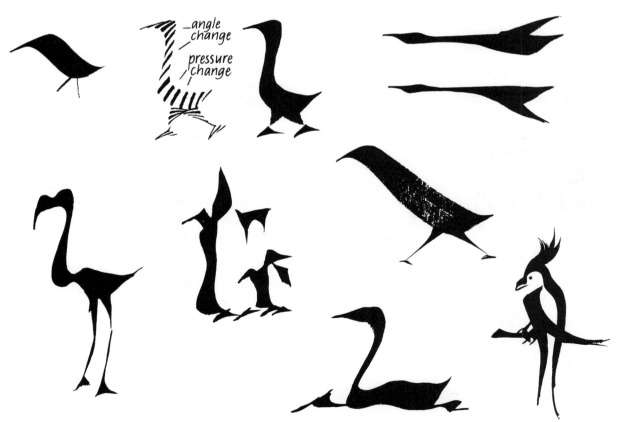

2-18. Calligraphic birds, which begin and end with light pressure for crisp hairline entrance and exit strokes.

Roman Minuscules

The model for the roman lowercase, or minuscule, alphabet for brush is based on humanistic script, the Renaissance hand from which the earliest typefaces were derived and which still inspires type design. The humanist scripts of the fourteenth and fifteenth centuries were the manuscript hands, or bookhands, used in Italy, and derived from the Carolingian models of the ninth and tenth centuries. The humanist minuscules are simple, open, and legible by design (fig. 2-19). They were used with roman capitals, to which scholars and scribes had returned with the revival of classical learning in the fourteenth century.

Monoline

The underlying structure of any alphabet is the essential shapes of the letters without the character that the calligraphic tool provides—the skeleton without the flesh (fig. 2-21). The monoline form of the roman minuscules in figure 2-20 shows the adjustments made to geometric forms (circle, square) for a more pleasing letter design.

To the eye, a perfect circle actually seems wider than it is tall, as does a perfect square. To adjust for this perception, the letter *o* is drawn taller than it is wide—as an oval—so as not to appear weighty. The *c* and *e* are also slightly oval; the bowl of the *e* should not be too large or it will overpower the bottom counter space. The *n* (and its related letters, *a*, *u*, and *h*) is also narrower than its body height so the counter will appear to have the same volume as that of an *o*. (The counter of the *o*

2-19. Sample of humanistic manuscript hand from the fifteenth century.

appears smaller because it is completely enclosed.) The eye tends to lengthen horizontals (the crossbars of the *t* and *f*) and diagonals, so these letter parts must be drawn shorter or thinner to compensate. The *k*, *v*, *x*, *y*, and *z* are narrower than they are tall so they do not look too wide; the *s* is purposely narrower than a full circle because its diagonal curve makes it look wider. As with *e*, the top counters in the *k* and *x* are always made slightly smaller than the bottom counters to give the letters stability and balance the counters optically. In general, the volume of counter space should be visually equal in all the letters.

2-20. Three roman minuscules shown in relation to circle and square

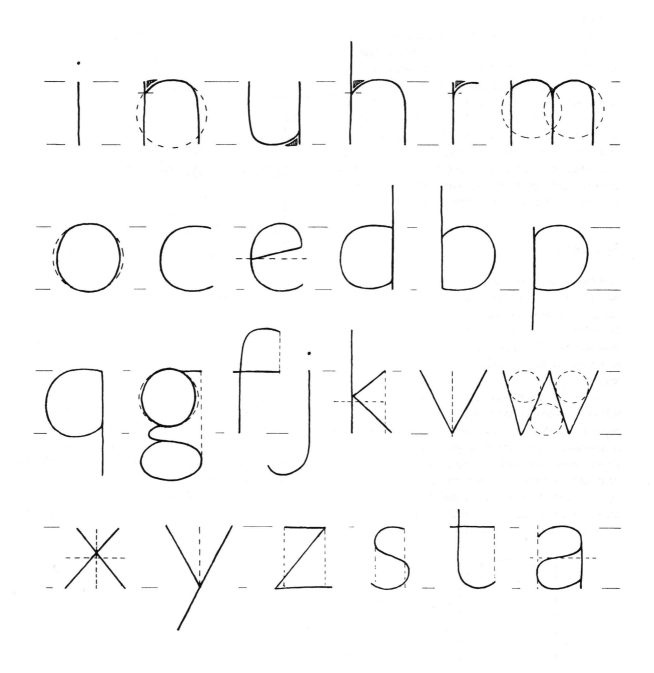

2-21. Roman minuscule monoline showing adjustments from geometric shapes.

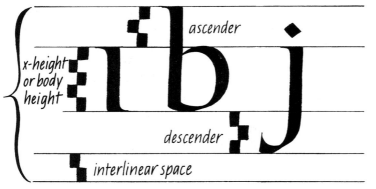

A lined page; x marks the writing spaces.

2-22. Rule guidelines based on measurement using the width of the brush for x-height, ascenders, descenders, and interlinear space.

Ruling Guidelines

With edged-brush writing, the weight of the letters is determined by the ratio of tool width to body height, or x-height. Small squares, pulled horizontally to reflect the width of the tool and stacked corner to corner, establish the x-height of the letters for ruling guidelines (fig. 2-22). The ideal x-height for roman minuscules is five brush widths; this height makes the letters most like the historical pen models for humanist script.

Ascenders and descenders should be at least three brush widths above and below the x-height. When you make guidelines, consider the entire unit (ascender/x-height/descender) as the ruling for each line of writing. An additional measure of space, one or two brush widths, between ruling units assures that ascenders and descenders will not overlap. (See the discussion of drafting equipment under "Studio Equipment and Supplies" in chapter 1 for tips on making and using guidelines.)

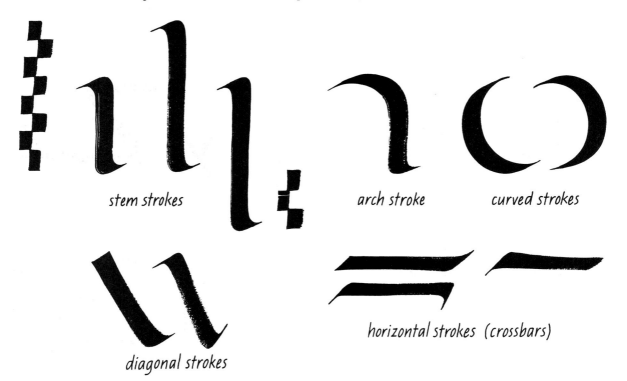

stem strokes

arch stroke

curved strokes

diagonal strokes

horizontal strokes (crossbars)

2-23. Basic strokes for roman minuscules.

Basic Strokes

At first you will want to work at a steady brush angle (the angle of the edge of the tool to the writing line) of approximately thirty degrees, a natural angle to a right-hander. Left-handers may have to cock their wrist or rotate their paper as much as ninety degrees to find a comfortable writing position and maintain the brush angle. The good news for lefties who write by hooking their hand around and writing from the tops of the letters is that gouache dries quickly, so you will not be as likely to drag your hand through wet paint. Left-handers may also benefit from alternate brush holds in which the hand does not rest on the paper.

For roman minuscules the basic strokes (fig. 2-23) are: a vertical, or stem, stroke, either at body height or as an ascending or descending stroke; an arch or branching stroke, out of or into a vertical (for *n*, *m*, *h*, *u*, *r*); a curved stroke (for *o* and the related letters *c*, *e*, *b*, *d*, *p*, *q*); a diagonal stroke (for *k*, *v*, *w*, *x*, and *y*); and a horizontal stroke (for *z* and the crossbars of *t* and *f*). The top edge of a crossbar should touch the x-height guideline. Descenders and ascenders should be at least three brush widths below or above the x-height; their terminals should match those of vertical stems.

Other strokes found in roman minuscules are the *a*, *e*, and *g* bowls, right-to-left diagonal strokes for the *k*, *v*, *w*, *y*, *z*, the diagonal curves of the *s* and *g*; and short arch strokes for the *r*, *c*, *f*, and *s* (fig. 2-24). The *t* and *f* each has its own variation of the stem stroke. The arch of the *m*'s branching stroke is narrower than the *n*'s arch.

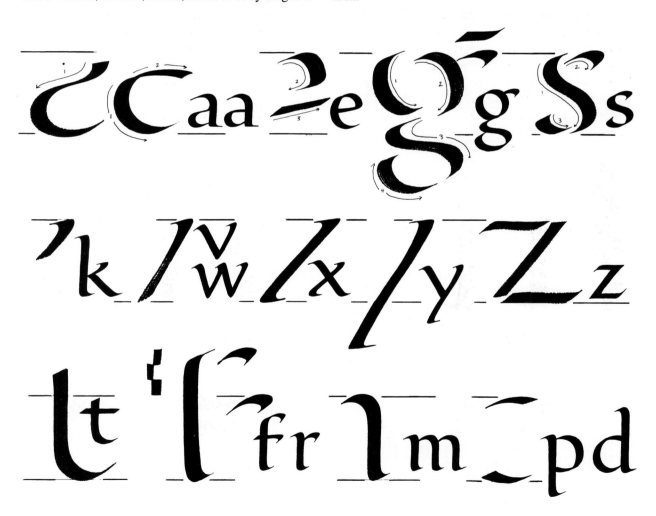

2-24. Other strokes found in roman minuscules.

beginsfavor

beginsfavor

2-25. Monoline roman minuscule in a word of sample letters, and that monoline as the skeleton of a sans-serif word.

The top of the *c, s,* and *f,* and the branching stroke of the *r* are short strokes slightly flattened from the oval and are made with a flatter, or more acute, brush angle so they do not become too heavy. The joining strokes at the top of the *d* and *q* bowls and the bottom of *b* and *p* are also made with a flatter edge angle. Crossbars and horizontal strokes on the *z, t,* and *f* are made with a flattened brush angle so they do not become too heavy. The same applies to the diagonal of the *e,* which originates above the halfway point of the first curved stroke. Edge angles and/or pressure should be adjusted on the different diagonal strokes to be sure that they are the same weight as the stem strokes.

The use of common basic strokes, with slight weight adjustments to horizontal and diagonal strokes to prevent heavy spots, gives the alphabet an overall family resemblance and a harmonious design.

Sans Serif and Informal Roman Minuscules

Sans serif letters have no exit strokes or added finishing strokes. A selection of sans serif letters is shown here with the roman minuscule skeleton inside the letters (fig. 2-25). They are five brush widths tall and have a steady diagonal brush-edge angle. Sans serif letters look simple but are not necessarily easier to make than serifed letters. A moment of hesitation or a slight cutting in or cutting out movement at the terminals—the beginning and end of each stroke—will clean them up so the brush fibers do not leave a ragged edge. Allow the terminals to pierce the guidelines so the letters do not fall short of the five-brush-width x-height. Curved letters should also intersect the guidelines.

beginsfavor

2-26. Informal roman minuscules made at a constant brush angle.

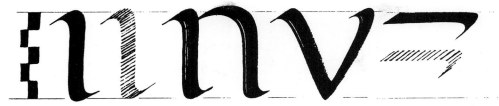

informal roman minuscules (fixed-angle serifs)

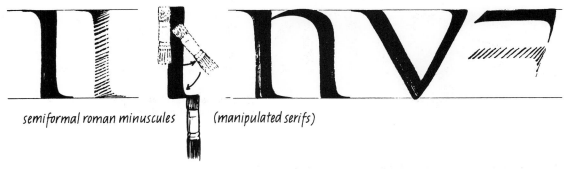

semiformal roman minuscules | *(manipulated serifs)*

2-27. Letters with fixed angle serifs and letters with manipulated serifs.

Another version of the roman minuscule has an exit stroke creating a serif at the same angle used to make the rest of the letter (fig. 2-26). This informal roman minuscule is recommended for those who are trying brush lettering and have not had previous pen experience.

Semiformal Serifs

Starting with a flat edge angle and changing to a diagonal angle in the serif produces a more formal letter, called a semiformal minuscule (fig. 2-27). The angle change creates a graceful fillet, or curve, inside the serif, and an angular corner on the opposite side of the stroke. Horizontal strokes in this semiformal alphabet also must have a change of brush angle at the end (twist to a steeper angle); diagonals also have manipulated entrance and exit serifs in which the brush edge angle becomes steeper or flatter, depending on the direction of the diagonals. This kind of tool manipulation or twisting is easy to do with the brush. Letters with curved strokes require no manipulation. A number of variations can be achieved by varying the serifs (fig. 2-28). The full alphabet exemplar is shown as semiformal letters (fig. 2-29).

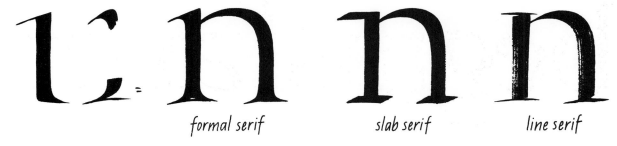

formal serif *slab serif* *line serif*

2-28. Serif variations can modify an alphabet's design.

roman minuscules

a b c d

j k l m

r s t u v

2-29. Exemplar: semiformal roman minuscules.

efghi

nopq

wxyz

Alternative Letter Design

Alternative letterforms for certain characters may be used, depending on context, design, and personal preference. For example, in figure 2-30, the *y* is related to the *u* instead of the *v*, the *g* is related to the *d*, and the *a* has an alternate bowl. Manipulating the brush to add weight to the terminals; making monoline letters (without the thicks and thins of the edge angle); condensing, expanding, or altering the basic skeletal shape; and changing the proportion of letter height to tool width all are possible design alternatives (fig. 2-31).

2-30. Commonly used alternative letters.

a jack *b* jack

c jack *d* jack

e jack *f* jack

g jack

2-31. Alternative designs for roman minuscules: (a) sans serif; (b) Optima-style with manipulated terminals; (c)monoline; (d) based on an alternative *o* shape; (e) condensing the basic skeleton; (f) expanding the basic skeleton; (g) changing proportion of body height to tool width, in this case, shortening.

Italic Minuscules

The brush italic model is based on a variation of the humanist script of the Renaissance, often referred to as chancery cursive because of its use in papal briefs (fig. 2-32). A compressed and sloped roman minuscule using a diagonal (thirty- to forty-degree) pen-edge angle, italic combined legibility with speed to become an ideal manuscript hand. The skeletal shape is an ellipse whose central axis slopes five to twelve degrees to the right. This elliptical *o* fits into a parallelogram, and the other primary italic letterforms, *a* and *n,* can be drawn within this parallelogram to plot their unique shapes (fig. 2-33). Figure 2-34 shows sample italic letters, revealing their monoline structure, or skeleton.

Ma uedi Eunoe, che la deriua:
Menalo ad esso; et come tu se usa,
La tramortita sua uirtu raniua.
Com' anima gentil; che non fa scusa,
Ma fa sua uoglia de la uoglia altrui,
Tosto com' è per segno fuor dischiusa;
Cosi poi che da essa preso fui,
La bella donna mossesi; et a stato
Donnescamente disse, uien con lui.
S'i hauesse Lettor piu lungho spatio
Da scriuer; io pur cantere in parte

2-32. Chancery cursive from the fifteenth century.

2-33. Monoline italic shown in relation to a parallelogram.

2-34. Sans serif italic, revealing the monoline structure, or skeleton.

Basic Strokes and Letter Families

Italic minuscules are drawn with a slightly steeper brush angle (thirty-five to forty-five degrees) and are generally taller (five to six brush widths tall) than roman minuscules; the stem stroke is thinner. Ascenders and descenders are about four brush widths above and below the body height and have the same serifs as the body-height stem strokes (except *q*).

The stem stroke has elliptical entrance and exit strokes. Branching strokes, in the letters *n*, *m*, *h*, *b*, *p*, *k*, *r*, and *u*, start low in the stem with a steep brush angle and separate from the stem (or, in the case of the *u*, branch into the stem) about midway on the body height (fig. 2-35). With the brush, the arch on *n*, *m*, and *h* is made a little differently than with the pen: there is

a slight amount of swelling when coming around the curve, then care is taken to recover the brush angle at which the first vertical was made.

The lowercase *a* and the related letters *g*, *d*, *b*, *q*, and *p* acquire a distinct brush shape in the bowl: slightly increase the pressure before making a tight curve at the bottom of the bowl, then steepen the brush angle as you snap up to meet the beginning horizontal stroke (reverse these directions for *b* and *p*). A short, flat horizontal joins with the stem stroke to overlap the top of the hairline stroke on *a*, *d*, *g*, and *q* (fig. 2-36).

The *o* is made in two mirror strokes with the same brush angle as the stem stroke, with the hairlines at eleven and five o'clock. The *e* and *c* begin with the *o*'s left stroke; on *e*'s second stroke, the brush angle flattens as it comes around the bowl to connect into the

2-35. Stem strokes and letters with branching.

2-36. Letters with *a*-bowls.

2-37. Letters with *o*-bowls.

2-38. Horizontal strokes.

56 Introduction to the Edged Brush

2-39. Diagonal-stroke letters.

first stroke. The top stroke of the *c* flattens out slightly from the *o*'s curve (fig. 2-37).

Crossbars and horizontals (*t, f, z*) are made with a flatter brush angle than the stems, to make sure they appear thinner and for contrast; edge in with a slight hairline or start bluntly (fig. 2-38). On letters with diagonal strokes, such as *v, w, x,* or *y,* the slope line of five degrees will bisect the counter. Diagonals have the same entrance angle as the stem strokes (fig. 2-39).

With the brush, pressure can be increased slightly at the ends of crossbars and horizontal strokes and on the end of the *k*'s diagonal leg to swell the stroke. Descenders on *f, g, j, p,* and *y* can be constructed with short curved strokes pulled into the hairline, or they can be pushed through toward the left with a quick release of pressure (*g, j, y*). When branching out of the

stem and around the curve of an arch, as on the *n, m,* or *h,* be sure that, by adjusting brush angle or pressure, the final downward stroke is the same weight (thickness) as the first stem. Where diagonals join, as on the *v* or *w,* angle the first stroke steeply at the bottom to finish the corner, avoiding a blunt intersection of strokes. The second diagonal of the *x* can come down from the top or be pulled up from the baseline, but it should intersect above the midpoint of the first diagonal. Top counters are always slightly smaller for balance on such letters as the *k, x,* and *z.* The *z* can be made with the brushstrokes at the same angle throughout, or with the diagonal at a flatter angle, for more strength (fig. 2-40). The entire italic alphabet appears in figure 2-41.

increase pressure to swell stroke same weight on stem strokes uneven weights

pull push

finish corner in first stroke pull down pull up same brush angle throughout flatten brush angle for diagonal

2-40. Letter refinements for italic; controlling pressure.

italic minuscules

a *b* *c* *d* *e*

k *l* *m* *n* *o*

u *v* *w* *x*

2-41. Exemplar: semiformal italic alphabet.

f g h i j

p q r s t

x y y y z

llvt

informal letters (fixed-angle or unmanipulated serifs)

llvt

semiformal letters (manipulated serifs)

2-42. Unmanipulated and manipulated serifs.

Semiformal Serifs

A more formal design for brush italic is achieved by using a slight angle change in the serif (fig. 2-42). The italic minuscule model shown in figure 2-41 has semiformal serifs. In this alphabet the serif is begun at a fifteen-degree brush angle; moving into the stem the brush is twisted to a thirty-degree angle; then it is flattened back to fifteen degrees at the bottom to exit for the serif. These quick angle changes as you enter and exit the main stem stroke create the curved fillet and the sharper corners of the stroke. This manipulated serif is also used on ascenders, descenders, diagonals, and horizontals; curved strokes have no serifs and so are made like the informal italic.

aggðkh

Qefrrss

2-43. Alternative letter designs.

ɸ eɸ ɸ ɸ

2-44. Ampersands for italic minuscule, based on the letters *e* and *t* (Latin *et,* meaning "and").

Alternative Letter Design

A number of alternative designs are shown in figure 2-43. An alternative *a* and *g* borrow from the roman minuscule; for italic they are given a more elliptical bowl and are made to match the italic letter slope. An alternative *d* borrows from the uncial alphabet, having a curved ascender; a variation of the *k* has a closed bowl instead of a diagonal arm at top. The bottom of the bowl on the *b* can sweep through the vertical, like the bottom of the *p*. A lowercase *q* can be adapted from the italic capital *Q*; the *f* can end at the baseline; and the *r* can extend its horizontal stroke in a reverse curve. Copperplate is the design source for an alternative *r* and *s*; they take on their own distinct character when done with the broad-edged tool.

The ampersand is derived from the ligature of the letters *e* and *t*, for the Latin word *et*, meaning "and."

Some kind of ligature of the *e* and the *t* of any alphabet you are using is the basis for the ampersand; add flourishes and invent your own to meet your specific design needs (fig. 2-44).

You can change the whole nature of an alphabet design by modifying or eliminating serifs (fig. 2-45). An informal serif bounces off the baseline at a steeper angle; a more formal serif might sit flat on the line. An implied serif can be created by simply adding pressure at the terminals, much like the terminals in the typeface Optima.

The basic shape of the alphabet can be changed by expanding, compressing, or changing the slope of the ellipse underlying the structure of italic (fig. 2-46). These variations must be consistent in all twenty-six letters if the alphabet design is to be rhythmic and harmonious.

beginsfavor

casual, informal serif

beginsfavor

formal serif, little letter slope

beginsfavor

Optima-style sans serif

2-45. Italic variations based on serif treatment.

beginsfavor

no letter slope, short body height

beginsfavor

more letter slope, narrow letters

beginsfavor

shorter body height, flatter angle

2-46. Changing height, weight, density, and/or slope of alphabet.

Flourishes

Flourishes for brush italic follow the same principles as for pen italic. Keep the counter spaces open—curved, not curled—and try to flourish to the outside of the word, phrase, sentence, or paragraph. Certain points on letters lend themselves to expansion or exaggeration: for example, the *t*'s crossbar, the ascenders on the *d*, *h*, and *l*, and the diagonal of the *k* (fig. 2-47). With a brush, you have the option of increasing pressure and swelling the stroke, or letting the paint run out at the end of the stroke to emphasize texture. It is harder to push the brush than the pen, and you cannot rock up on the corner as you might with a more rigid tool; you must discover which lines it can make by experimenting. Your touch must be light, and your grip must be one that lends itself to multidirectional movement (fig. 2-48). The amount of paint on the brush should be controlled: not so little that you run out before the flourish is complete, but not so much that the line is blobby and thick, drawing attention to itself rather than decorating or embellishing.

2-47. Flourishes for italic minuscules. Experiment and make it look graceful and energetic!

2-48. Write with energy and speed as you build confidence so letters really dance!

Flourished Italic Capitals

The capitals used with chancery cursive had the basic structure and proportion of roman capitals but often had letter slope and embellishments. A scribe could use his writing tool to make the decorative letter for a block of text or for titles (fig. 2-49). After movable type was invented in the fifteenth century, writing masters had to compete to attract patrons, and the handwritten styles became elaborate and extremely decorative. In the seventeenth century, a style called copperplate, originally designed for metal engraving with a pointed tool called a burin, included a design for capitals, which also influenced modern flourished cap design (see chapter 5 for copperplate with the pointed brush). The edged brush adds speed and texture and some originality to the design. Swash caps, as they are commonly known, are useful as paragraph openers for pen writing and even for use with type.

Much personal interpretation enters into the design of flourished caps; the aesthetic standard is different from person to person, region to region. The models shown here are the authors' preference and design (fig. 2-50). Strokes that are natural to the chisel-edged brush—pulled strokes with gradual swellings or pressure changes, snapping around the curves of the bowls, and flourishes created with a light touch—are built into this design.

2-49. Flourished capitals used with chancery cursive a written sample from the fifteenth century.

FLOURISHED ITALIC CAPS

A B C D

I J J K

P Q Q R S

X Y

2-50. Exemplar: flourished italic caps.

E F G H

L M N O

T U V W

Y Z

Basic Strokes

The fundamental strokes used to construct flourished italic caps are shown in figure 2-51. Use a stem stroke that is seven to eight brush widths high. The brush enters from the top right and ends with a serif stroke pulled with a very flat brush angle across the base. All letters with vertical stems use this basic stroke; a thinner version would be used for the first stroke of the *A*, *N*, and *M*. Many of the caps, including *B*, *G*, *Q*, *P*, *D*, and *R*, share a common branching bowl stroke in which the brush branches out of or heads into the stem, snaps around the curve and flattens at the bottom or top. Horizontal strokes are made with a flattened brush angle (fifteen degrees). You can edge in with a hairline and exit with some weight added for swell (as in the horizontal of the *T* or *L*); the exit can be at a steeper brush angle to weight the end of the stroke. The basic flourish stroke that comes into the stem from the left begins with very light pressure.

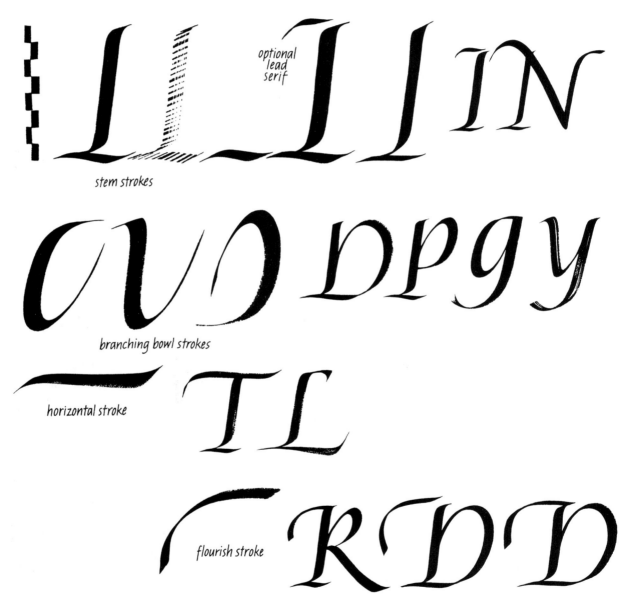

2-51. Basic strokes used in many of the capital italic letters.

Flourished caps are slightly more uniform in width than roman caps. The curved letters, such as *C*, *O*, *D*, *G*, and *Q*, are more oval than fully round in shape. The *M* and *W* are still extra-wide letters because of the number of strokes they contain. Take care to adjust the brush angle and pressure for letters with diagonal strokes to ensure that all the diagonals appear to have the same weight. The first stroke of the *A* and *M*, and the second diagonal of *X* can be pulled up from the baseline (fig. 2-52). The descender of the *J*, *Y*, and *G* can be pulled from the left, blending into the hairline, or it can be pushed to the left; the same applies to the bottom stroke of the *S*. This push is done with a quick release of pressure; it is a feathery light flourish that can only be created with a brush (fig. 2-53). The brush is not an easy tool to push—you will have to practice to develop a very light touch.

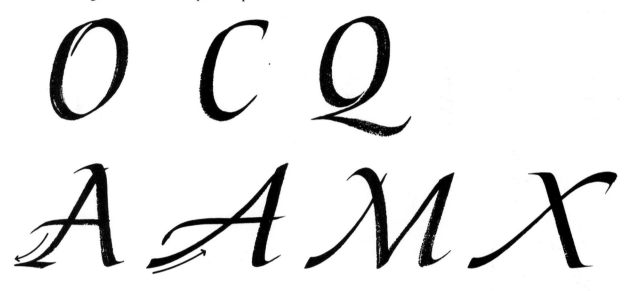

2-52. *Top:* Curved letters are more oval than round. *Bottom:* Strokes pulled up from the baseline.

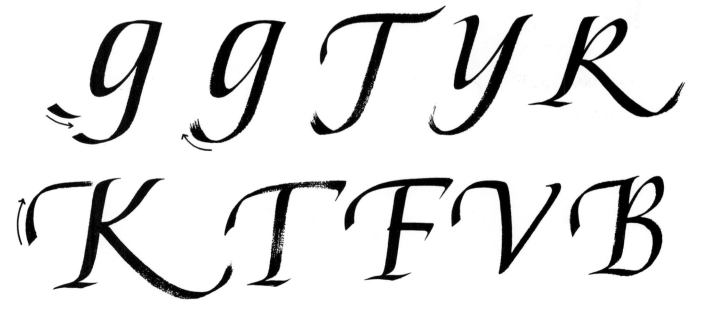

2-53. Push strokes, done with light pressure.

Flourish Strokes

Once you have created the basic structure of each letter, you can add as many embellishments as there are terminals to attach them to, as long as the letterform is not changed. Flourishes to the left of the stem are made with curved strokes using an angle change; these can be applied to any capital with a vertical stem. On letters that offer many opportunities for flourishes, such as the *K, N, M,* or *H,* be discerning: instead of attaching flourishes to every terminal, choose just one or two (fig. 2-54). In all-capital words, the first cap could be a flourished cap and the other caps could be sloped romans—flourished caps look better and are more legible individually, rather than strung together in a row.

Alternative Letter Design

Many of the flourished italic caps are adapted from the copperplate alphabet; the alternative letterforms for I, *S, E,* and *G* are examples (fig. 2-55). Every lettering artist who uses flourished caps gives them his or her own distinctive design and personal touch (fig. 2-56).

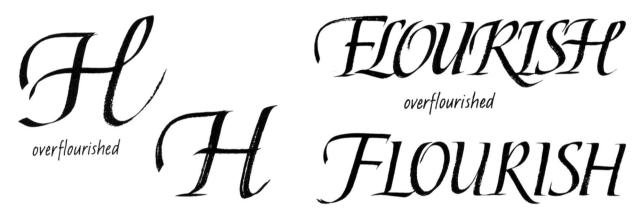

2-54. Be discerning: do not be tempted to add a flourish wherever there is an opportunity. Choose only one, for emphasis.

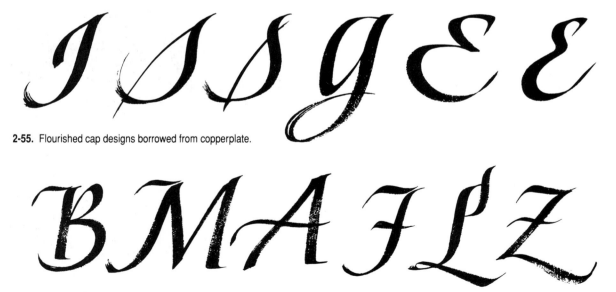

2-55. Flourished cap designs borrowed from copperplate.

2-56. Variations in personal style.

3. More Edged-brush Lettering

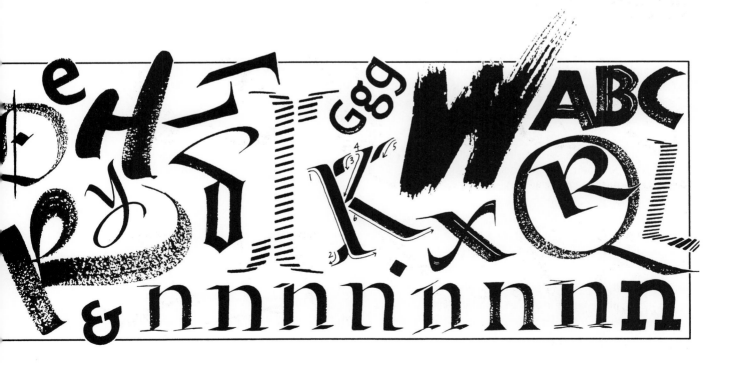

Roman Capitals

The elegant and finely proportioned roman capital, or majuscule, letters are based on geometric forms: the circle, square, and triangle. Brought to perfection by the Romans in the first and second centuries A.D., the monumental letters were painted directly onto stone with the chisel-edged brush, then incised. The Roman, or Latin, alphabet was based on the Greek alphabet and originally contained twenty-one letters: *A, B, C, D, E, F, G, H, I, K, L, M, N, O, P, Q, R, S, T, V,* and *X.* After the Roman conquest of Greece in the first century B.C., the Romans added the Greek letters *Y* and *Z* to accommodate Greek words containing these letters (the Roman lexicon did not use them). The letters *J, U,* and *W* were added to the Latin alphabet during the Middle Ages.

Characteristic of roman capitals are the bracketed serif, the tall body height (ten or more brush widths tall), and vertical strokes that are approximately twice as heavy as the horizontal strokes (fig. 3-1). This two-to-one ratio in weight is produced by using a fairly flat brush angle (about fifteen degrees for vertical strokes and thirty degrees for horizontal stokes) and adjusting the amount of pressure.

Roman capital letters can be classified based on their width, as it relates to their height (see fig. 3-10, the exemplar of monoline roman capitals). The letter *O* (and *Q*) made with an edged brush can fit a square, as shown in figure 3-2 (as a skeletal or monoline letter, it would appear more compressed). The other wide letters, *C, D,* and *G,* are slightly narrower because only one side carries the full curve. The *M* and *W* are a bit wider than the square. Medium-width letters are about four-fifths as wide as they are tall: *A, H, K, T, U, V, X, Y, Z;* the *N* may be included in this group, but it may also be wider. Narrow letters are half as wide as they are tall: *B, E, F, J, L, P, R, S.* (The *I,* comprising just a vertical stroke and the serifs, stands on its own.) Letters with curves at the guidelines (*C, G, J, O, Q, S*) may cut through the line to make them appear equal in size to the other letters.

Other optical adjustments are also necessary. The crossbar or midarm on the *A, H, E,* and *F* must be raised or lowered to make the top and bottom counters, or negative shapes, appear equal. In addition, the height at which strokes intersect the stem or diagonals cross on the *B, P, R, K, X,* and *Y* must be adjusted. Similarly, the top half of the *S* is made smaller than the bottom for optical balance; the top half of the *B* and *K* should be visibly smaller. The points on the *A, N, V,* and *W* and the top of the *M* pierce the guideline so that they do not appear diminished. Refer to figure 3-10, the annotated illustration of monoline caps, for these and other tips.

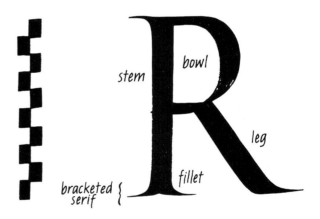

3-1. The structure and parts of the roman capital *R.*

3-2. The letter *O,* outside edge to outside edge, can fit a square based on its height.

The basic *I* stem of roman capitals begins at the cap height (top) guideline with the brush edge angled very slightly downward (a negative brush angle), as shown in figure 3-3. Be sure your brush is carefully paletted to hold a sharp edge. Pull lightly toward the right, then twist the brush counterclockwise as you add pressure and come around the fillet (the flattened curve made where the serif joins the stem), pivoting the brush as you pull downward. At the bottom, twist back to the slight negative angle and release pressure as you snap the brush off to the right, making a hairline exit. Always enter at the top left and exit at the bottom right. Finish the foot serif by placing the brush inside the stem and sliding out to the left while releasing pressure. Finish the head serif by pulling into the stem with an almost flat brush angle. Try to make all four

serifs look alike, with a graceful, flattened curve in each fillet and hairline terminals of equal length. The overlap in making the serifs produces a "dent" at the top and bottom; for a "finished" letter, you can retouch the dent to make a cupped serif. The double-stroke serif can produce a subtle swelling of the stem at the top and bottom, giving it a refined, waisted look. (Lessening the pressure in midstroke will let you achieve an even more tapered look.)

Start the *O* with the left curve, placing the brush just under the top guideline at a fairly flat angle (fig. 3-4). Pull out, then down into the curve. For the right side of *O*, overlap the hairline of the first stroke, pull up, out, over, and into the curve. Overlapping the hairlines strengthens the letter while maintaining the thick and thin contrast. The *O* (and *O*-related curves) calls

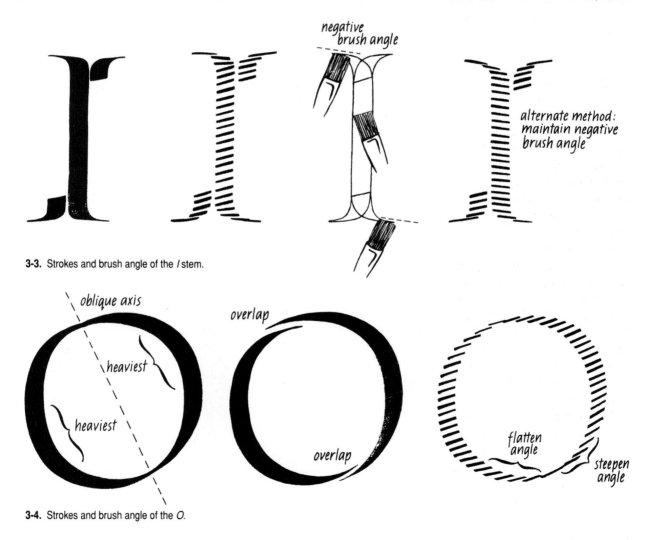

3-3. Strokes and brush angle of the *I* stem.

3-4. Strokes and brush angle of the *O*.

for some brush manipulation or pressure adjustment to avoid heaviness at the bottom of curves.

Make horizontals only half as heavy as the stem strokes by using the brush angled at an angle of about thirty degrees or slightly more (fig. 3-5). The brush angle is not as fixed as it is with the pen because pressure plays such an important role. Begin and/or end horizontals well inside the stem to avoid leaving any gaps or spaces.

Many horizontals end with a half serif (E, F, T). The tops of the C, G, and S are flattened curves that may be considered curved horizontals and have a similar terminal (see fig. 3-5). Twist the brush to ninety degrees at the very end of the stroke, pulling downward and releasing pressure at the same time. Try not to pause in making this pivoting motion, or you will produce a fan shape. These terminals should relate visually to the head and foot serifs.

The bottom horizontal of the E, L, and Z is begun with the brush angled backward (see fig. 3-5). At the end of the stroke, twist clockwise to ninety degrees while releasing pressure and pulling up. The bottom of the C is made similarly. Depending on the composition of the particular brush you are using, the tool itself may help to finish the half-serif strokes with a "snap-off" action as the bristles regain their upright position.

The bottom of the S and J is begun with the brush at ninety degrees (see fig. 3-5). Pull down while twisting clockwise to about thirty degrees; hold that angle and finish the flattened curve, heading upward at the end to overlap the previous stroke.

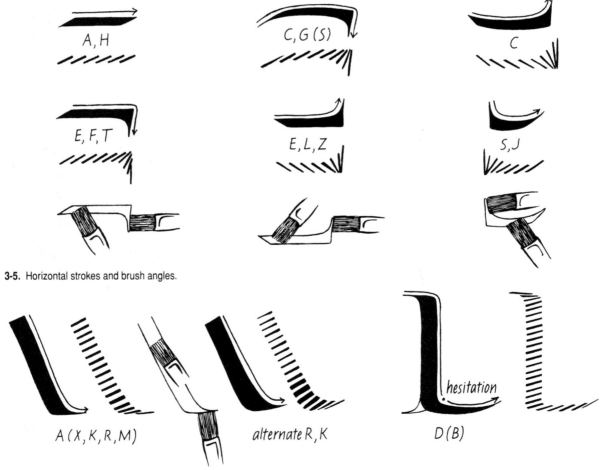

3-5. Horizontal strokes and brush angles.

3-6. Diagonal strokes and the bottom of D and B bowls, with brush angles.

Diagonals that go from top left to bottom right are begun with an angled brush that twists to almost flat at the bottom (fig. 3-6). Adjust the angle and pressure so that the weight of the stroke corresponds to that of the stem stroke. The stroke is similar for the *R*, *K*, *X*, *A* (and even the final stroke of the *M*), though the degree of diagonal varies. Eliminate the interior serif on this diagonal. For the leg of the *R* and *K*, you may want to swell the stroke slightly by applying pressure.

The bottom of the *D* and *B* is an extended stroke made with a hesitation as you move from vertical to horizontal (see fig. 3-6). This hesitation gives some roundness to the interior join (at the top of the *D* and *B*, the join of stem and horizontal is sharp). The *E* and *L* also require this hesitation to round the join at the bottom.

The points on brush-made roman capitals are relatively tight but rounded. The bottom points of the *V*, *W*, *M*, and *N* call for pivoting the outside corner of the brush, then releasing pressure to let the bristles become upright and exit in a hairline (fig. 3-7). This hairline serves as an outside guide for the connecting stroke. The apex of the *A*, *M*, *N*, and *W* requires a fine-line continuation of the outside edge of the preceding stroke. Without pausing, pivot the brush to make the point, then pull down to finish the diagonal stroke.

Begin the horizontal at the top of the *T* and *Z* with the brush at ninety degrees; pull down slightly, then pause, reverse direction, and pull up while twisting to about thirty degrees (fig. 3-8). This method will give you a flattened interior curve; as a finishing touch, you can fill in the little chink of white space at the top to make a sharp corner. It is also possible to make this half serif with a single upward movement and twist.

The top horizontal of the *D*, *B*, *P*, *R*, *E*, and *F* is started well inside the stem to avoid a gap at the join (see fig. 3-8); any unevenness in the top of this line can be filled in with a touch of the brush's edge. An alternate way to construct this join is to begin inside the stem at a ninety-degree brush angle, then twist to pull the horizontal stroke.

The letters *E* and *L* require three joining strokes at the bottom to make the interior curve (see fig. 3-8). Note that the stem stroke does not come down to touch the guideline as you pull right.

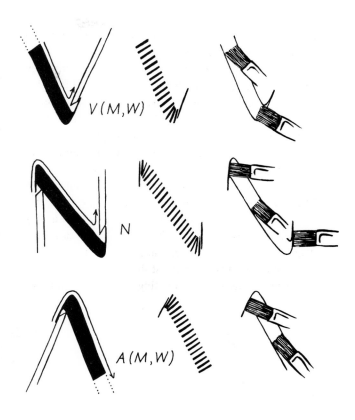

3-7. Pointed letter parts, with brush angles.

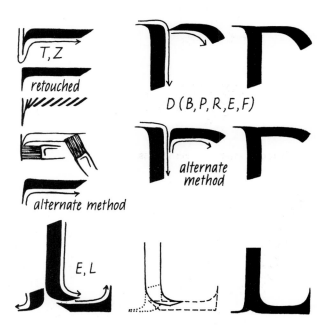

3-8. *Top left:* Top of the *T* and *Z*. *Top right:* Connecting a horizontal with a stem. *Bottom:* Bottom of the *E* and *L*.

The *P* historically had an open bowl. The *J* had a slight descender, but it may base-align with the other letters in its modernized version (fig. 3-9). For the ampersand you can lift the brush and readjust the long curve stroke as it passes through the diagonal.

Figures 3-10, 3-11, and 3-12 show the strokes used to make roman capitals. Figure 3-10 is a monoline version, showing the basic structure of the letters. Figure 3-11 shows the direction and sequence of strokes (called the *ductus*). A full alphabet of completed letters follows in figure 3-12.

3-9. Modernized *P* and *J;* the ampersand, or *and* symbol.

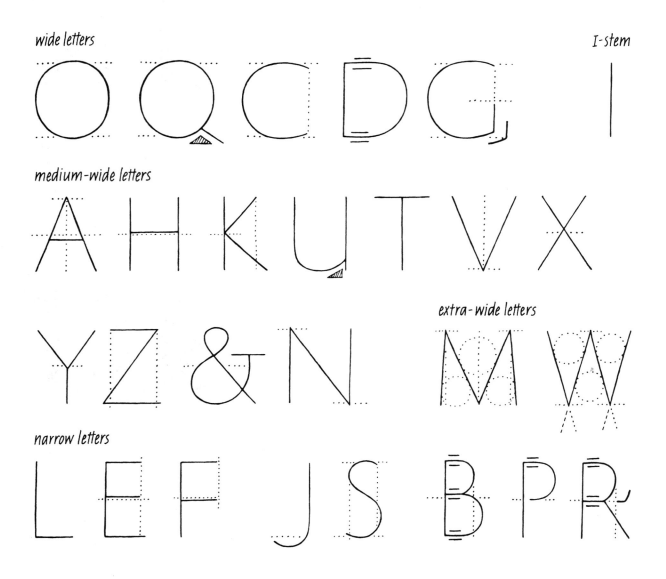

wide letters *I-stem*

medium-wide letters

extra-wide letters

narrow letters

3-10. Monoline roman capitals, showing letter widths and structure.

ABCDE
FGHIJK
LMNOP
QRST&U
VWXYZ

3-11. Ductus, or direction and sequence of strokes for roman capitals.

ROMAN CAPITALS

A B C

G H I

M N

3-12. Exemplar: roman capitals.

D E F

J K L

O P Q

R S T
U V W
X Y Z

Informal Caps

Informal caps are more simple and direct than classical roman capitals and are made with fewer strokes. For these less formal letters, you can modify roman capitals in several ways (fig. 3-13). You can shorten the x-height to seven or eight brush widths, simplify the serifs (use entrance and exit serifs only), and eliminate points at the apexes of the *A*, *M*, *N*, and *W*. The terminal on the horizontals of the *C*, *G*, *E*, and *F* may be less angled. The relative widths of the letters can stay the same, or you may want to introduce a bit more uniformity by slightly expanding narrow letters and compressing wide letters.

The basic *I* stem requires a more abrupt twist at the top and the bottom to make a sharper corner and anchor the serif at the guideline. Start with the brush flat to the guideline, pull to the right and twist quickly as you begin to bring the stroke downward. Make the apexes of the *A*, *M*, *N*, and *W* with a similar stroke, pulled on a diagonal instead of vertically (fig. 3-14).

For the horizontal at the bottom of the *D* and *B*, pause or lift the brush at the guideline before pulling the stroke to the right, to make sharp corners both outside and inside the letter (fig. 3-15). The horizontal at the bottom of the *E*, *L*, and *Z* also needs a pause or lift for a sharp corner. Then gradually swell the stroke by applying pressure and twisting counterclockwise; to exit, gently release pressure, letting the bristles become upright, and pull upward. This finish is not really a half serif but rather a flaring of the stroke that gives weight, stability, and polish to the letter (see fig. 3-15). The horizontals on the *C*, *G*, *E*, and *F* also end with a swelling made by twisting the brush; the result is like the half serif on the roman capitals but with a greater visible brush angle (see fig. 3-15).

Figure 3-16 shows a complete alphabet model of standard informal capitals. A second alphabet, shown in figure 3-17, is even more casual, with sloped letters, minimal serifs, less twisting, and generally more bounce and verve.

3-13. Classical roman capitals, compared with informal caps.

3-14. Basic *I* stem and diagonal on the *A*.

3-15. Horizontal strokes and terminals.

INFORMAL CAPS

A B C D

J K L M

R R S T

X Y

3-16. Exemplar: informal caps.

EFGHI

NOPQ

UVW

&Z

CASUAL CAPS

A B C D E
E F G H I J K
L M N O P Q
R S T U V W
X Y & Z

3-17. Exemplar: casual caps.

Adapting Other Alphabets to the Edged Brush

Most pen-made calligraphic alphabets can be made with the brush, and many typefaces can be adapted to the brush. Although you are not restricted to specific styles or faces because you are using a brush, certain ones adapt better than others to this tool. When written with a brush, the letters will have more texture, and the softness and flexibility of the tool will show in the structure and strokes of the letters. You may have to add a serif or finishing stroke to bring the bristles back together after adding pressure in a stroke and to make the terminals look crisp. The edged brush is better suited to writing large; brushes smaller than one-quarter inch are less precise and somewhat temperamental in their handling.

This section examines brush adaptations of several alphabets that are effective as large-scale writing and are useful for contrast in lettering design.

Rustics are more compressed and casual than roman capitals (fig. 3-18); they have a characteristic wedge as the top, or head, serif, a clublike foot serif, and a thin stem stroke. The *A* was usually made without a crossbar. Historically, rustics were written small-scale with a pen, for manuscripts, or large with a brush, on walls, serving as a kind of sign-writing version of the roman alphabet.

Uncials, very round and with a relatively short x-height (fig. 3-19), usually are recognizable by certain distinctive letter forms: *A, D, E, H, M*. A few letters have slight ascenders, and a rounded form of the *T* is often used with uncials.

Blackletter (fig. 3-20) comprises various compressed, angular manuscript hands that appear very dense on the page; they are also called gothic scripts. Blackletter often has a stem with abrupt, heavy head- and foot strokes, and a condensed rectangle for *O* and related letters.

The typeface Neuland, designed by Rudolf Koch in the 1920s, has a boldness and versatility that make it an extremely useful alphabet (fig. 3-21); adapting it to the brush imparts softness and texture. Neuland-style brush lettering is usually done with a very short x-height with no manipulation. Many personal interpretations are possible.

Sign Gothic, based on a sign-writer's alphabet and used for maximum legibility, is a sans serif style with a uniform stroke thickness that requires considerable brush manipulation for making the curves (fig. 3-22).

Optima, the typeface designed by Hermann Zapf in 1958, is the basis of another brush alphabet (fig. 3-23). Optima-style capitals have classical roman proportions but a very contemporary feel, with stem strokes that swell at the top and bottom, leaving the midstroke waisted. Constant subtle manipulation of the brush is required to make these refined letterforms.

These alphabets are just a sampling of the many calligraphic scripts and modern typefaces open to exploration with the brush.

RUSTICS

3-18. Exemplar: rustics.

IJIIOONNFF

AOEĥM

BCFGGĥI

JKLPQRS

TUVWXX

YYZ

3-19. Exemplar: uncials.

Blackletter

‡o o í í s s

aabcdefghíj
klmnopqrss
tuwvxyz M
ABCDEFGH

3-20. Exemplar: blackletter.

NEULAND-STYLE

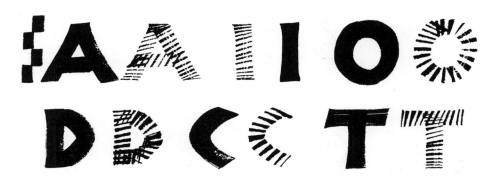

ABCDEFGHIJ
KLMNOPQRE
RSTUVW&
XYZ

TALL OR SHORT

BLOCKY WE

3-21. Exemplar: Neuland-style.

Sign Gothic

.'1 E E C C B B

Aa Bb Cc Dd Ee
Ff Ggg Hh Ii Jj
Kk Ll Mm Nn
Oo Pp Qq Rr Ss
Tt Uu Vv Ww
Xx Yy & Zz

3-22. Exemplar: Sign Gothic.

TTAARR

ABCDEFH

IJKLMNO

PQRSTUV

WXY&Z

AN

3-23. Exemplar: Optima-style.

Numerals

The numerals we use were not a Roman invention but were borrowed from the Hindu-Arabic culture and may have been developed in India, where they appear in inscriptions dating from the third century B.C. The shapes are different enough from the roman alphabet that they usually present a design challenge (fig. 3-24). The reverse curve in the *2*, in the *8*, and in the question mark, for example, has no counterpart in the letterforms. This curve tends to be too light in weight compared to other long strokes, a problem you can remedy with extra pressure. On diagonal strokes that extend from the upper right to lower left, as in the *7* and a version of the *3*, more weight must be added, or the stroke will be too weak; increase the weight by adding pressure or by using a flatter brush angle. Several numerals combine oval and circular shapes: *6*, *9*, and one version of the *8*. In many numerals, the top counter is smaller than the bottom counter for visual balance and

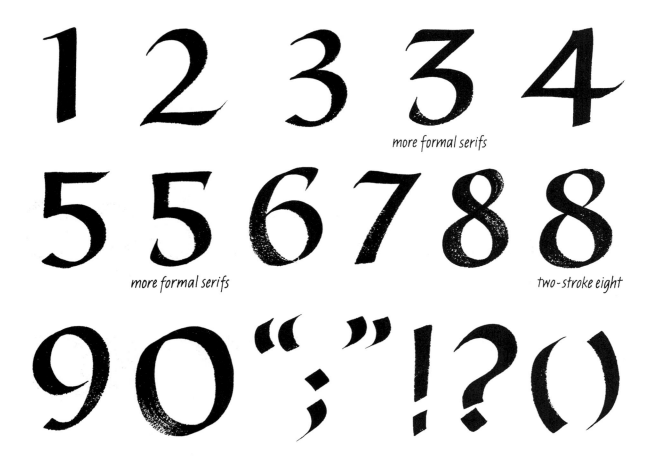

more formal serifs

more formal serifs

two-stroke eight

3-24. Arabic numerals and punctuation.

stability. Note that the horizontal of the *4* is lowered to allow ample counter space. The *0* is differentiated from the roman *O* by being oval shaped. Figure 3-25 shows the order and direction of strokes, or ductus, for numerals. Several have more than one design. Numerals look best between cap and body height; for shorter numerals, consider the old-style numerals, with ascenders and descenders (fig. 3-26).

To adapt numerals to a specific alphabet style, analyze the body height, weight, curves, slope, terminals, and other characteristics of the alphabet, and reproduce these characteristics in the numerals. Figure 3-27 shows numerals designed for a brush italic and brush Neuland-style.

Punctuation can be adapted slightly to relate to an alphabet's design.

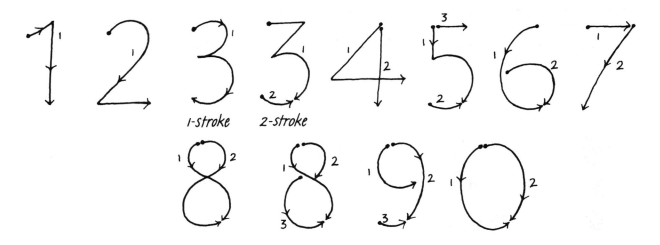

3-25. Ductus for numerals.

3-26. Old-style numerals with ascenders and descenders.

3-27. Numerals designed for brush italic, Neuland-style.

Variations and Play

Using the same size brush but changing the body height (x-height) of letters will produce variations in the density, or color, of the writing. The larger the x-height, the more lightweight the letters appear, because more "air" or white space is captured by the strokes. Letters made with a smaller x-height will appear bolder and heavier (fig. 3-28). Compression or expansion of the letterforms and the letter spaces also affects the ratio of black to white space and creates tension or looseness (fig. 3-29).

Changing other aspects of the letterforms, such as the shape of curves or the height of the ascenders and descenders also alters the look of the writing and can be used to enhance meaning (fig. 3-30).

dense

light

3-28. Changing the body height changes the density, or color, of the lettering.

squeeze

expand

3-29. Condensed and expanded letterforms at the same body height.

stretching

squared

equality

3-30. Modifying curves and ascenders/descenders.

The slope of the writing is another variable. Sloped writing with roman minuscule forms produces a pseudoitalic or oblique style (fig. 3-31). Remember, though, that sloping more than about twelve degrees from the vertical can distort the letters and interfere with legibility.

Modifying the serifs allows many possibilities for subtle variation of expression. Serifs can range from very formal (as on roman capital letters) to fanciful and imaginative (fig. 3-32). Be consistent throughout the alphabet when you change the serifs, and try not to close off counter spaces.

In designing a monogram, single word, or headline, you may want to explore ligatures (letters that share certain parts) or overlapping letters (fig. 3-33). With the brush, especially when you are using a textured paper or drier paint, considerable "read through" is possible in overlapping letters, which maintains some legibility.

parakeet·parakeet

3-31. A sloped roman, or oblique, style compared with a true italic.

3-32. Serif variations.

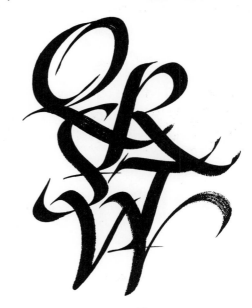

3-33. Sharing strokes and overlapping letters.

Conversely, exploding the letters or disconnecting the individual strokes can create liveliness or sparkle. This technique can also be used for a stencil-style lettering (fig. 3-34).

Writing very fast greatly affects the texture of the letters: the brush skims across the surface of the paper, not allowing the paint to sink into the minute depressions (fig. 3-35). The terminals may appear unfinished or "flyaway," and you may have unplanned pressure bulges—which only adds to the look of spontaneity.

Using a loose, two-finger brush hold and full-arm movement increases the rushed look of the writing (see the section on alternate holds in chapter 2).

Controlled pressure changes, along with twisting or manipulating the brush, can be used to redistribute weight in the strokes. You can create a bottom-heavy look or a lighter, spiked look with swelled or tapered strokes (fig. 3-36).

A unique feature of the brush is that you can use both sides of the tool, even flopping the brush onto its

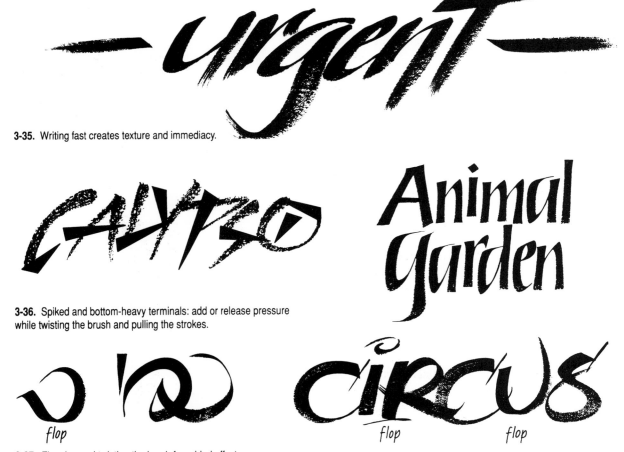

3-34. Exploded letters, or stencil style.

3-35. Writing fast creates texture and immediacy.

3-36. Spiked and bottom-heavy terminals: add or release pressure while twisting the brush and pulling the strokes.

flop

flop *flop*

3-37. Flopping and twisting the brush for added effects.

backside in midstroke; some interesting effects are possible with this technique (fig. 3-37). With a loose grip, the brush is extremely maneuverable; rolling or twisting as you move, you can turn the brush 360 degrees in a single stroke.

Flourishes seem very natural with the brush. Minimal flourishes can add a touch of zest or elegance, while less restrained flourishes may look exuberant (fig. 3-38).

Coupling the pointed brush with the edged brush can produce very delicate flourishes; let the pointed-brush mark become a natural extension of a corner or tapered stroke made by the edged brush. Overlaying loose, pointed-brush letters on edged-brush forms adds a carefree, playful touch (fig. 3-39).

Other brushes can be used like the standard chisel-edged brush to create interesting, unusual letters (fig. 3-40). The oval or filbert brush has a rounded head that makes a round beginning and cupped finish of the stroke (twist the brush slightly and lift off at the finish). Another kind of sign-painter's brush has a flat ferrule, long and full fibers, and a tapered, chiseled tip. With this brush you can start the letters with a chisel edge, but swell the strokes by increasing pressure, giving a pointed-brush effect in the middle of the stroke. A stiff, round stencil brush produces a distinctive look: letters are made with a series of short pulled strokes that have no edge or swell but give a very brushy, active line. Even a brush usually considered unsuitable and difficult to control can produce unexpected but appealing results. The fan brush, normally used to blend watercolors, produces an unusual and exciting stroke.

Sometimes concentrating on a single letter will help you to come up with new ideas, which can then be applied to a whole alphabet or a headline—or that single letter can be the basis for a logo design. Try to think of the individual parts of a given letter (the capital *R*, for example, has a stem, bowl, and leg), then let your imagination create and combine those parts in new ways (fig. 3-41). Work fast, disregard legibility, and do more, more, more! Do not hold back—try anything: a different brush hold, your nonpreferred hand, closing your eyes, not lifting off the paper. Review and critique your work later, and select your best examples.

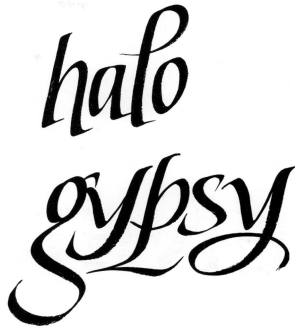

3-38. Minimal flourishing and more exaggerated flourishing.

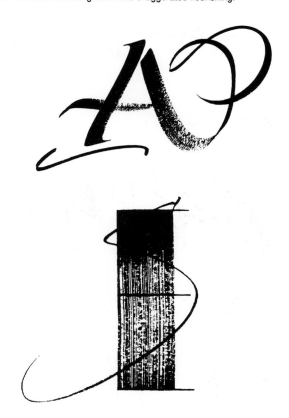

3-39. Combining pointed brush and edged brush for flourishing and overlays.

filbert brush

fan brush

(examples extremely reduced)

stencil brush

sign-painter's brush

3-40. Experiments with other brushes.

3-41. Playing with letter parts to push the form.

4. Introduction to the Pointed Brush

Starting Out

The pointed brush may be held like a pen, with the outside heel of your hand resting on the flat or sloped writing surface. In this writing position, the handle of the brush lies fairly low "in the valley" between thumb and forefinger, resting gently against the top knuckle (fig. 4-1). The chisel-edged brush, by contrast, is held more upright to keep the very tip of the brush in contact with the paper. The lower position for the pointed brush lets you use the side of the bristles to make the heavy strokes (see "Warm-Ups and Basic Strokes," later in this chapter).

In Eastern calligraphy the pointed brush is held more vertically; pressure and release from this position produce the unique character strokes. For Western writing, however, which is more uniform and rhythmic, a perpendicular pointed brush can produce irregular beginnings and ends of strokes (fig. 4-2). The flatter, penlike hold lets you use the side of the brush to give a clean, angled start and finish to the downstrokes.

Hold the brush loosely enough to allow finger movement as well as some wrist movement. Bend

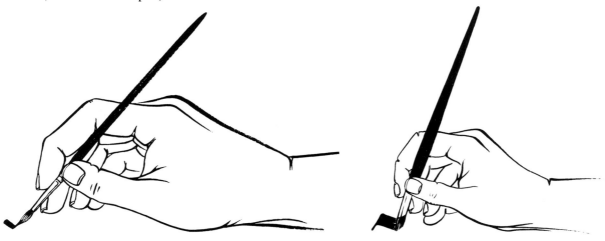

4-1. The hold for the pointed brush, compared with that for the chisel-edged brush.

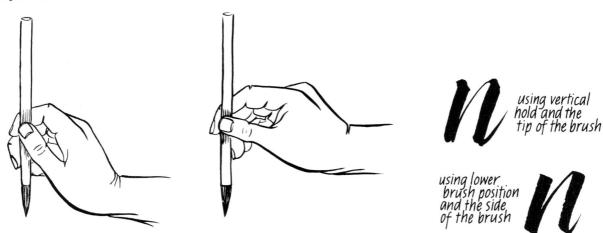

4-2. Eastern-style vertical holds may give an uneven start and finish to the strokes.

using vertical hold and the tip of the brush

using lower brush position and the side of the brush

your fingers slightly to pull the stroke down, while simultaneously bending your wrist. For the thin upstrokes, make a small adjustment in your brush hold to bring the very tip of the brush to the paper (see "Two Methods of Making Letters," later in this chapter). The larger the writing, the more wrist and full-arm action you will need.

For very loose and light gestures or flourishes, try holding the brush at the ferrule with just two fingers; lift your hand off the paper and keep the handle perpendicular (fig. 4-3). Move quickly and freely to produce spontaneous, delicate, dancing strokes.

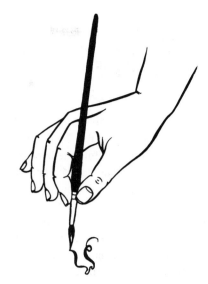

4-3. A loose, vertical hold for free flourishes.

Shaping the Brush

Bristles go out of alignment as you write. Frequent repointing will help you to make crisp letterforms. Shaping the brush also helps to distribute the paint through the bristles and remove any excess paint. On a matboard scrap or other flat surface, twirl the brush as you pull it across, to establish a good point (fig. 4-4). (A semiabsorbent material such as matboard allows you to control the quantity and thickness of the paint or ink.) If you are using a small paint cup, try twirling along the inside edge of the cup and pulling up as you reload the brush.

As you write, glance often at the point before you touch it to the paper. You may need to rotate the brush to control which part of the tip actually produces the mark, especially if the brush is crimped at the end or has other idiosyncrasies.

Some brushes require less pointing than others; certain synthetic brushes are very snappy and hold their shape well. Other brushes, especially softer, natural-hair Oriental brushes, demand more pointing. In general, repoint the brush whenever you reload it with paint or ink, or more often if it loses its shape.

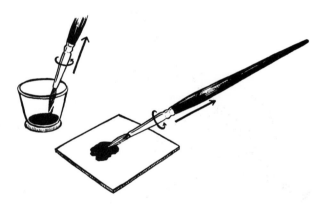

4-4. Repointing the brush on matboard or the side of a paint cup.

Hand and Body Positions

Place your hand slightly below the writing baseline and to the right of where you plan to write, with the brush tip pointing toward the northwest. The writing trails along behind the brush (fig. 4-5).

4-5. Position your hand below the writing line and to the right.

The paper should be in a position that is comfortable and natural for your writing; for right-handers that may be aligned straight in front of your body or angled to the left (fig. 4-6). The line or area of the paper on which you are writing should be in clear view and most accessible; move the paper as you write to maintain this optimal relationship. Some people like to use an extra scrap of paper as a hand guard to prevent the deposit of skin oils onto the paper. Often this measure is critical for pen writing, but it is not always necessary with the brush, whose multiple fibers glide over the surface.

Left-handers may need to cant their paper to the right so they can pull, instead of push, the strokes and to prevent the writing hand from dragging through the wet ink or paint. The brush tip points northeast, and the writing follows behind the brush (see fig. 4-6).

Some left-handed writers prefer to place the paper at a ninety-degree angle to the body to give free movement to the writing arm. Experimenting with the paper's position usually solves any initial difficulty left-handers have in using the pointed brush. ("Hookers" may need to modify their usual grip or place the paper straight on—note that gouache dries faster than ink and may help in avoiding hand smudges. Using papers that are more absorbent, such as some printmaking papers, may also help.)

The Writing Support

Many people who write regularly with the pointed brush prefer a slightly sloped surface, whether it be a drafting table or a writing board. Others like a flat table, and a few choose a sharply sloped surface of perhaps thirty to forty-five degrees or even steeper (fig. 4-7).

A flat support allows you to write anywhere, but on large pieces you may have to bend over or reach out. A very sloped surface brings your writing into better visual perspective, but you may have some dripping if you are using a loaded wet brush. Find the slope that is most comfortable for you and best fits the particular project or situation.

A drafting table allows you the choice of standing up or sitting on a stool to work (or you can half-stand, bracing yourself against the stool). Standing permits more body movement and is easier on your back.

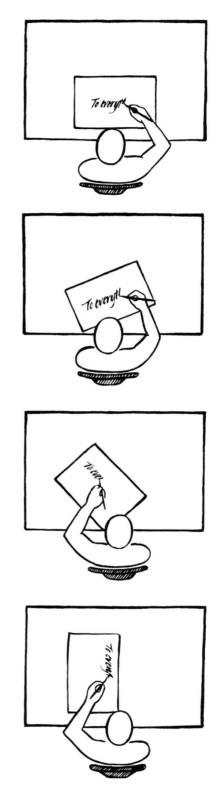

4-6. Positioning the paper for right- and left-handers.

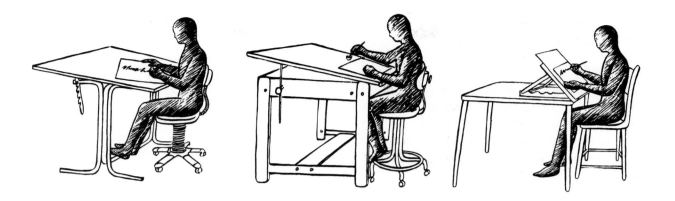

4-7. Choosing a writing support and a flat or sloped surface.

Warm-ups and Basic Strokes

To begin warming up with the pointed brush, try drawing loose, free-form strokes, first with light pressure using the tip of the brush, then with heavier pressure using the side (fig. 4-8). Alternate pressures to create lines of continuous gesture writing (fig. 4-9). These free, expressive lines can be done to music, in response to pitch, beat, volume. Try a variety of controlled-pressure movements, in which you consistently increase and decrease the pressure for each stroke, to create patterns or just isolated marks (fig. 4-10).

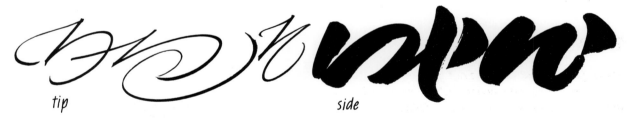

tip *side*

4-8. Free-form warm-up strokes using the tip and side of the brush.

4-9. Gestural writing to jazz music.

Devise repeatable abstract marks to understand and practice the effects of a particular movement with the brush and to create pleasing designs or decorations (fig. 4-11).

Zigzags and arcades will also help build a writing rhythm and consistency in thicks and thins. Alternate the tip and the side of the brush (fig 4-12).

In your warm-up session, try to relax and to gain control: these are not really contradictory goals. As confidence and speed build, the forms will also improve. Warming up will help you to produce the desired result sooner. Often, in commercial work, deadlines intrude, preventing a full warm-up session; the warm-up may simply be repeated writing of the headline or word until you reach your peak and produce on paper what is in your mind's eye.

Making Choices

It is important in developing your own pointed-brush script to write within your comfort zone, in order to produce the most natural and spontaneous-looking lettering. Determine the stroke height and weight that work best for you, without going to extremes (fig. 4-13). Also trust your own aesthetic preference.

Choose the letter slope that is most comfortable to maintain, to help you keep that slope consistently (fig. 4-14). Your preferred slope may be related to your own handwriting. Again, avoid extremes, such as backsloping or an exaggerated forward slope, which can distort the letterforms. Most people use some forward slope, though vertical script is certainly acceptable.

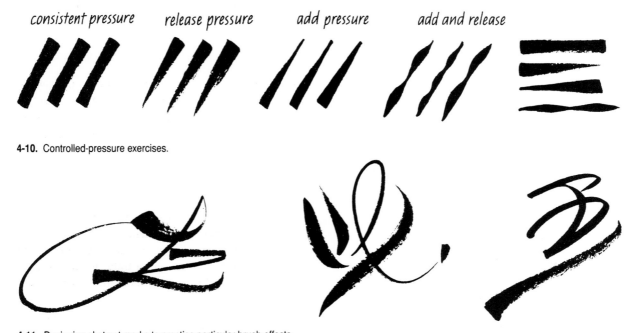

4-10. Controlled-pressure exercises.

4-11. Designing abstract marks to practice particular brush effects.

4-12. Using the tip and side of the brush to practice zigzags and arcades.

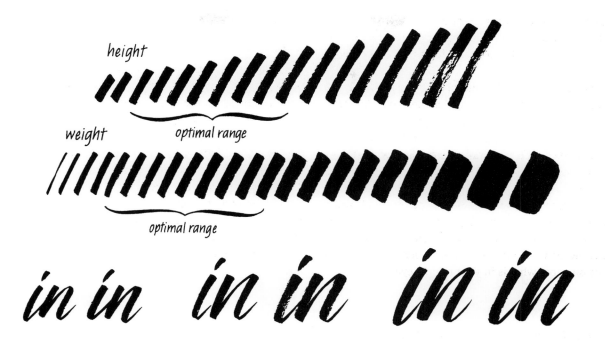

4-13. Choose the height and weight of stroke that are comfortable for you.

4-14. Choose a slope that feels natural and comfortable, and maintain it consistently.

Terminals

One distinction between edged-brush (and pen) writing and pointed-brush writing is the angle produced at the terminals of the strokes (fig. 4-15). With either type of brush, try to maintain the angle consistently.

Basic Moves

The primary downward stroke begins and ends with a pause that helps clean up the terminals (fig. 4-16). At the finish of the stroke, pause; then either lift off or pull back into the stroke with a light, flicking movement (especially if this stroke does not connect to a subsequent stroke).

The speed at which you pull down the stroke will also affect the visual result. With more speed, you may have some tapering at the middle and a more textured look. Slower movement will fill in more of the stroke but may also cause some wobbles. For upstrokes, use light pressure on the tip of the brush, and swing up in a slightly arcing motion (fig. 4-17). Your approach to pointed-brush writing—using "pressure-and-release" or "broken strokes," both discussed in the next section—will also affect your speed and the look of the letters.

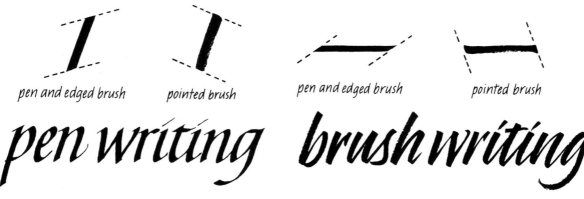

pen and edged brush *pointed brush* *pen and edged brush* *pointed brush*

4-15. The angle at the stroke terminals for edged-brush (and pen) writing compared to that for pointed-brush writing.

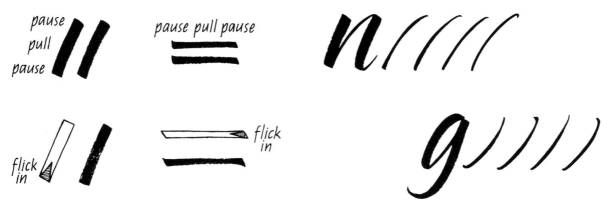

pause pull pause *pause pull pause*

flick in *flick in*

4-16. Make basic strokes with a pause at the beginning and end; finish with an optional flick in.

4-17. Upstrokes made with brush tip, using an arcing motion.

Two Methods of Making Letters

Letters made with the pointed brush are "shaded," that is, composed of thick strokes and thin strokes. Thick strokes are made with a downward pull of the brush; thin strokes are made with an upward swing. To produce thick strokes, apply pressure and use the side of the brush; to make thin strokes, release pressure and use the point (fig. 4-18).

Either of two methods can be used to make letters: broken strokes or pressure-and-release. The broken-stroke method uses a series of separate strokes that appear connected. The strokes are made rapidly, and control over the letterform is gained by stopping and

lifting between strokes. Note that thin strokes connect at the corners of the thicker downstrokes (fig. 4-19).

Adjusting the position of your hand slightly may help you to make thick and thin strokes. Extending the brush enables you to use the side of the bristles more easily. Retracting the brush by bending your fingers a bit will allow you to write with the fine tip (fig. 4-20). The illustrations exaggerate this change of position to let you see the difference more clearly; while you are writing, this shift may be almost imperceptible. You will also need to adjust pressure: heavier on the downstrokes and lighter on the upstrokes.

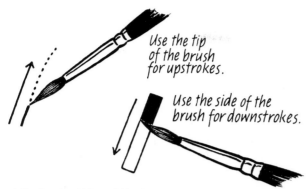

Use the tip of the brush for upstrokes.

Use the side of the brush for downstrokes.

4-18. Creating thicks and thins by using the side or tip of the brush and adjusting pressure.

The broken-stroke method lets you make quick strokes that can look lively and spontaneous, and it allows you to create a dramatic contrast between thicks and thins. This approach may also help you to write downstrokes with a uniform thickness, without tapering at the bottom.

With the pressure-and-release method, you keep the brush in contact with the paper and adjust pressure when you change the direction of the stroke, using heavier pressure for the downstrokes and lighter pressure for the upstrokes. As you release pressure, pull the brush to the lower right corner of the stroke and

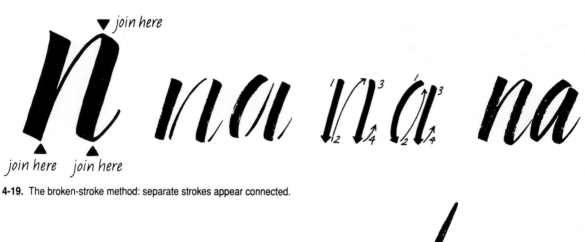

▼ *join here*

▲ *join here* ▲ *join here*

4-19. The broken-stroke method: separate strokes appear connected.

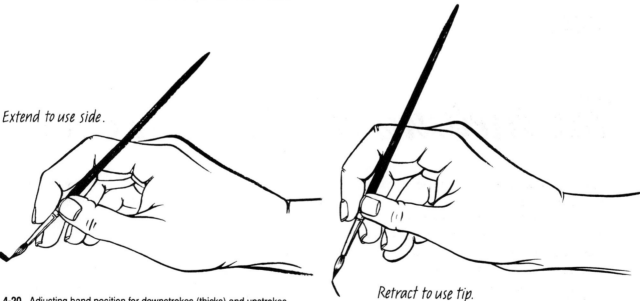

Extend to use side.

Retract to use tip.

4-20. Adjusting hand position for downstrokes (thicks) and upstrokes (thins).

move onto the brush tip before you begin the upward movement (fig. 4-21). Moving onto the brush tip, with the bristles straight again, will help you avoid creating extra thickness at the juncture of the downstroke and the upstroke.

Be careful not to release the pressure too soon as you pull the downstroke, or the stroke will taper and appear weak at the baseline. With the pressure-and-release method, you can make the strokes more slowly, and you may be able to achieve a more integrated letterform. This approach also may be more suitable for small writing.

The end results using these two methods will be similar but not identical (fig. 4-22). Try both approaches, and use the one that is more natural for you and gives the look you want.

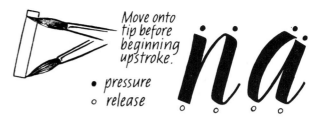

4-21. Pressure-and-release method: the brush stays in contact with the paper.

4-22. Results of the two methods are similar but not identical.

A Basic Pointed-brush Script

Contemporary pointed-brush script may be quite individualized, and it draws upon many sources: italic pen writing, sign painting, copperplate, handwriting, and even Eastern brush character writing. It is a cursive style, usually with connecting strokes, that is based on minuscule, or lowercase letterforms. The writing techniques discussed here apply to the capitals as well as lowercase, but capital letters are discussed separately, in chapter 5.

A basic pointed-brush script should have a rhythmic pattern of upstrokes and downstrokes. The downstrokes are heavier and quite uniform in width, or weight, from top to bottom; they contrast with the thinner upstrokes. The script may be written with pressure-and-release or broken strokes. Your own basic script will carry a personal signature—a certain style or flair or emphasis—but it should be consistent, rhythmic, and legible. From a basic script, you can develop many variations that reflect mood or content.

Stem strokes may have a clean edge at the top or begin with an entrance "tick," or you can choose a longer, curved entrance stroke on some letters, especially at the beginning of a word (fig. 4-23). To produce the tick, pull slightly to the right before applying pressure and pulling down. Pause at the beginning and end of downstrokes to establish a crisp edge. Finish letters with an upward connecting stroke. The connector is slightly curved and held quite close to the stem.

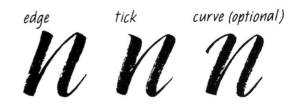

4-23. Choosing a style for stem strokes.

Families of Letters

As with pen italic, many letters in a pointed-brush script are closely related in structure; the main families are built around *a*, *n*, and *o*. Figure 4-24 shows what to watch for in making these three primary letters and the related letters. Figure 4-25 shows the ductus, or direction and sequence of strokes, as well as the pattern of thicks and thins, for a basic pointed-brush script (minuscules). Figure 4-26 shows the brush-made letters for the alphabet. If you use pressure-and-release instead of broken strokes, adjust pressure where each new stroke is indicated. Figure 4-27 shows variations of the *s* and *r*, while figure 4-28 shows the old-style numerals, with short ascenders (*6* and *8*) and descenders (*3, 4, 5, 7,* and *9*). Note the roundness of the zero, to distinguish it from the compressed letter *o*.

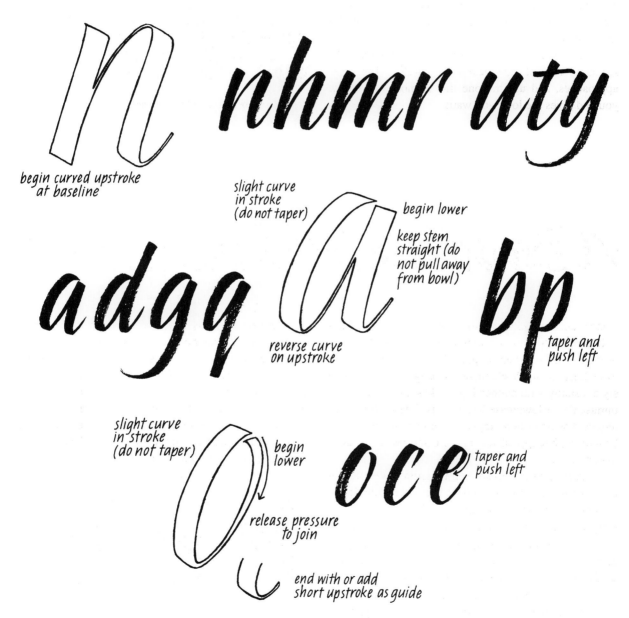

4-24. Main letter shapes, with related letters.

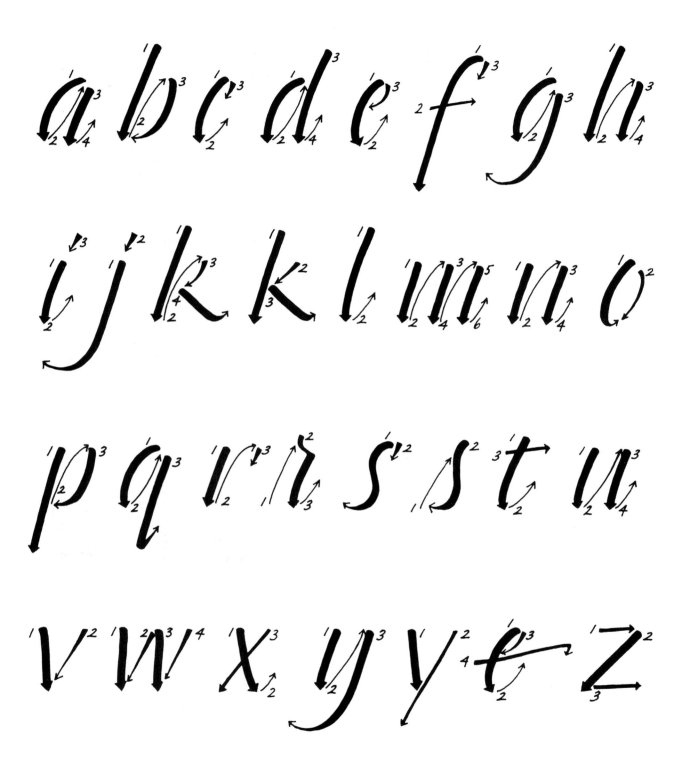

4-25. Pressure, sequence, and direction of strokes for a basic script.

pointed-brush script

a b c d e f g h

i j k k l m n o

p q r r s s t u

v w x y y e z

4-26. Exemplar: a basic pointed-brush script.

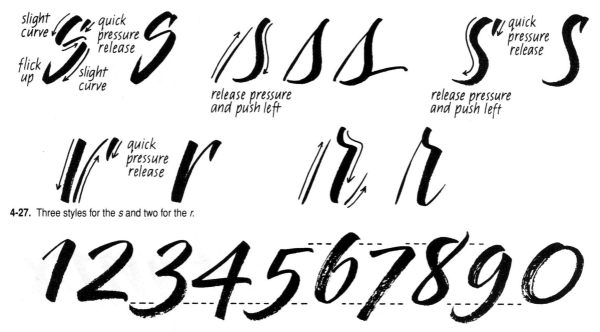

4-27. Three styles for the *s* and two for the *r.*

4-28. Numerals with short ascenders and descenders.

Brush Positions

As with pen writing, the usual movement in making letters is from top to bottom, left to right. Following the stroke diagram in figure 4-25, make separate strokes as shown or adjust pressure where each new stroke is indicated. For downstrokes and upstrokes, the brush is held to the right of the letter, pointing northeast. On horizontals, it is held directly underneath, pointing north. For diagonals, as in the leg of *k*, hold the brush above the stroke, pointing southwest (fig. 4-29). Adjust the brush position as needed for *x* and *y* diagonals. In general, hold the head of your brush perpendicular to the stroke.

Descenders and Ascenders

Descenders (in the letters *f*, *g*, *j*, *p*, *q*, and *y*) extend below the writing line or baseline. Curved descenders (in the *g*, *j*, and *y*) are made in one stroke. Finish the curve by pushing the brush to the left and releasing pressure as you lift off the page with a quick movement (fig. 4-30). Ascenders (in the *b*, *d*, *f*, *h*, *k*, and *l*) extend above the body height or x-height of the letters;

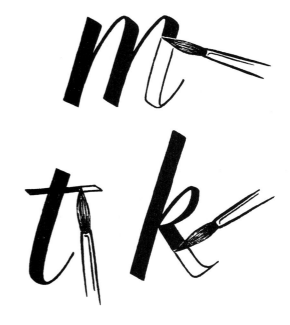

4-29. Three main brush positions for letter strokes.

110 Introduction to the Pointed Brush

the *f* has both an ascender and descender (fig. 4-31). Be sure to make ascenders tall enough to prevent the letters from being misread (*h* mistaken for *n*, for example). The letter *t* is taller than the body height but shorter than ascenders. Personal aesthetics determine, in part, the height of ascenders and descenders, as does the range of your hand movement in making a comfortable, natural stroke. Usually, however, ascenders and descenders are not greater than the body height, and they may be shorter, as long as legibility is maintained.

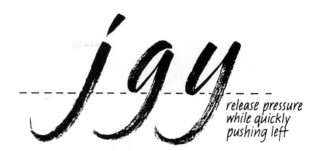

4-30. Curved descenders.

Crossbars

The horizontal crossbars on the *f* and *t* are thinner strokes (as are the horizontal strokes on *z*). They may end with a downward flick, an upward lift, or by pulling back into the stroke (fig. 4-32). In each case, the stroke is made with the brush positioned underneath it.

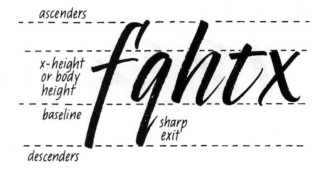

4-31. Choose a height for ascenders and descenders that maintains legibility.

Finishing Strokes

For balance and finish, certain letters with open curves (the *c*, *f*, *r*, and *s*) need an added terminal stroke. This is a short stroke made by pulling down while quickly releasing pressure (fig. 4-33). The top horizontal of the *z* may also take this finishing stroke.

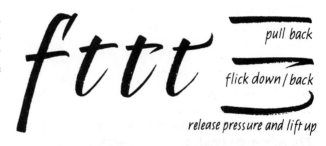

4-32. Finishes on crossbars.

Troubleshooting

To produce a clear, legible script with the pointed brush, pay special attention to the common problems shown in figure 4-34. Try to make the downstrokes using uniform pressure from top to bottom, with a crisp start and finish. (You may later decide to use particular features, such as a tapered downstroke, as variations.) Aim for a distinct contrast between thicks and thins, and keep the connectors delicate. Keep the counter shapes (the interior spaces bounded by the letter strokes) clean and open, though compressed. Try to be consistent in the weight of strokes, the compression of letters, and the slope of your writing.

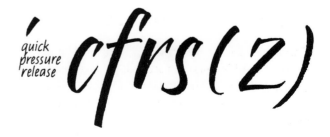

4-33. Add short finishing strokes on top curves and on the z.

u a

Nearly close the top
of the <u>a</u>, to avoid
confusion with the <u>u</u>.

e e e

Keep the <u>e</u> bowl open;
use either a downstroke
or an upstroke.

mr mr

Avoid tapering (releasing pressure)
at the bottom of downstrokes.

an an

Gently curve upstrokes and
keep counters open; do not
cut off the interior spaces.

v w v w slope slope

Avoid backslanting left diagonals,
to keep a consistent slope.

yk yk

Maintain contrast
between thick and
thin strokes in
each letter.

du du

Bring upstrokes to the top of the body
height, rather than halfway up.
Keep counters open, not cut off.

xy xy

Right
diagonal
thinner

nh nh

Make ascenders long
enough to prevent confusion
with other letters.

g g

On <u>a</u> shapes, barely curve the left
stroke to avoid a "dogear" look.

Ln Ln

Keep connector strokes more
diagonal than horizontal,
close to the stem.

bt bt

Pause at the beginning
and end of strokes to
ensure a crisp finish.

4-34. Avoiding some common problems.

Joining Letters

The entrance and exit on terminals influence the look and rhythm of the writing. Even though entrance and exit strokes may not actually connect all the letters to each other, they give a sense of joining and help to create visual pattern in a word, a line, or on a full page. Together with height, weight, and slope, the entrance/exit/connector style characterizes your basic writing script (fig. 4-35). From this foundation many variations are, of course, possible.

Connecting strokes are really extended exit strokes. They may touch the succeeding stroke at its midpoint or at the waistline (fig. 4-36). Do not join at the tops of ascenders.

If you are using the broken-stroke method, the connector will usually bump into the letter that follows. With this method you will make more lifts of the brush, but the lettering will look connected and flowing as long as you use some care in the placement of each new stroke.

Figure 4-37 shows letters connected by arced or slightly curved exit strokes. Make the connectors consistent and try to reflect the character of the writing; for example, a lightweight, rounded script might call for more curved and delicate connecting strokes. The exit strokes connecting letters in figure 4-38 are sharper and make a reverse curve. Tapering and curving the finish stroke allows optional connections: you can join the letters or keep most of them separate, bringing the finish stroke slightly below the baseline (fig. 4-39). Note that a connecting stroke is usually absent if the letter ends with a stroke pushing left (*b, j*).

A sans serif alphabet will have no connectors or entrance/exit strokes (fig. 4-40). The lettering is strong, graphic, and legible. It is a good alternative script to have in your repertoire. Another style, with quick-flick entrance and exit strokes, also has few if any connections, though it is serifed (fig. 4-41). The flick at the beginning is a downstroke; at the end it is an upstroke after a pause. Some aspects of this style of writing resemble Eastern character writing.

4-35. Choosing a style for connectors (entrance and exit strokes).

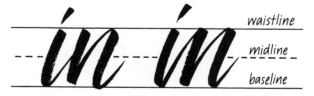

4-36. Joining letters at the midline or waistline.

abcdefghijklmn

4-37. Curved connectors.

abcdefghijklmn

4-38. Sharp, reverse-curve connectors.

abcdefghijklmn

4-39. Tapering and curving the finishing strokes.

abcdefghijklmn

4-40. Sans serif letters.

nopqrstuvwxyz

4-41. A quick-flick finish to strokes.

5. More Pointed-brush Lettering

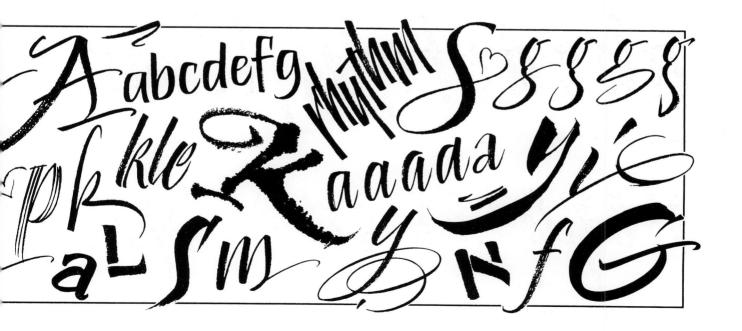

Alternative Minuscules

In developing your own basic pointed-brush script, you will make choices about the form and construction of certain letters. In general, try to be consistent in form, pattern, and rhythm. If, for example, you choose a variant *a* bowl, use it throughout your writing, and make other letters in the *a* family (the *d*, *g*, and *q*) in the same manner.

In writing headlines or short, expressive phrases, you can explore a larger palette of design forms. The headline, phrase, or word should work as a single design unit or *gestalt*; you may want to experiment and mix or push the forms to achieve this. But if the word or phrase is intended to be immediately legible, the letters must still be recognizable, individually or at least in context. Avoid weak letterforms—retain in some way the underlying structure of each letter—and take care that one letter cannot be mistaken for another by the reader.

Pointed brush script can allow you more freedom and variation than pen scripts do; for one thing, it does not carry the same weight of tradition. Sources for ideas are many, both historical and contemporary: you can look to typefaces, signs (both professional and "naive"), historical manuscripts, and handwriting for new forms and constructions.

The *a* Family

The bowl of the *a* and other letters in the same family (the *d*, *g*, and *q*) can be closed in several different ways to lend a certain look to your writing (fig. 5-1). Compare also the one-story *a* with the two-story version, as in the heading above.

The bowl on the *b* and *p* (the reverse of the *a* shape) is often closed by pushing the curved stroke left to join the stem; or you can give the appearance of closure by pausing and flicking inward with quick pressure release. An extended base, a one-stroke *b*, and a connecting loop are other possibilities. A slight reverse curve on the bowl of the *p* and *b* adds some flair (fig. 5-2).

Finishing Strokes

The letters *c*, *f*, *r*, *s*, and sometimes *z* may look weak or incomplete at the top without the addition of a short finishing stroke. This stroke may be a downward extension of the main stroke, a curved or squared serif, or it may resemble the jot on *i* and *j*, looking like a separate stroke (fig. 5-3).

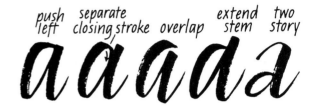

5-1. Variations on the *a* (and the related letters *d*, *g*, and *q*).

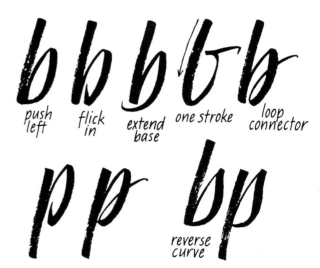

5-2. Other ways to construct the bowls of the *b* and *p*.

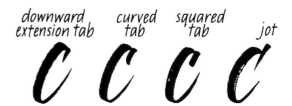

5-3. Some options for finishing strokes on *c*, *f*, *s*, and *z*.

Ascenders

An alternative *d* is based on the uncial form, with the stem bending left in a curve or arc; the letter can be made in two strokes or in three strokes (fig. 5-4).

Letters with ascenders (*b, d, f, h, k, l*, and sometimes *t*) may have a loop. To make the loop, curve the heavy stem stroke slightly, then add a lightweight stroke to the right by pulling downward (fig. 5-5). You can, of course, make the loop with one integral stroke (heading up, then down), but many calligraphers find it easier to control the shape of the loop and weight of the line with two strokes.

The *e*

The *e* may be flourished slightly by extending the bowl-closing stroke to the left. Or you can slightly modify the shape of the bowl itself: an upward stroke to close the bowl makes it a bit more open, while a low overlapping of the strokes makes a narrowed loop similar to the *e* in Palmer-style handwriting. A rounded capital form works in many situations (fig. 5-6).

Descenders

Many varieties of the *f* are possible: with loops at the top and/or bottom, made with a curving upswept stroke, or omitting the descender (fig. 5-7).

The *g*, as well as the *j* and *y*, can have a looped descender; or the descender can finish with a flick up or be made straight and unadorned (fig. 5-8). An alternate roman form (as in this typeface) has a top bowl shaped like but smaller than an *o*, with an "ear" at the upper right, and an open or closed bottom loop; it lends itself to flourishing and exaggeration (fig. 5-9).

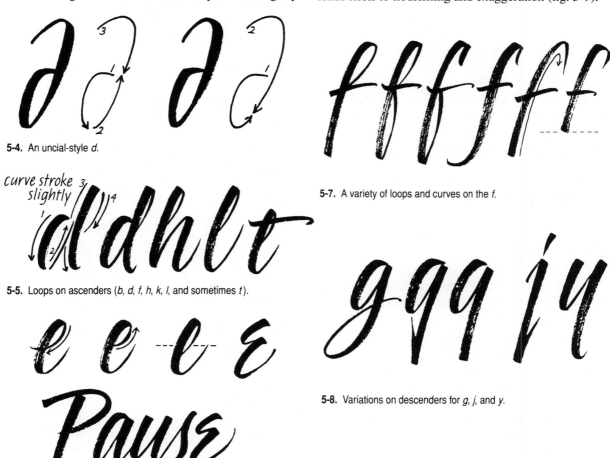

5-4. An uncial-style *d*.

5-5. Loops on ascenders (*b, d, f, h, k, l,* and sometimes *t*).

5-6. Variations of the *e*.

5-7. A variety of loops and curves on the *f*.

5-8. Variations on descenders for *g, j,* and *y*.

The *k, m, n, o,* and *q*

The letter *k* may be open or closed, and the leg can be attached to the stem in different ways (fig. 5-10). The *m* and *n* can have a connecting entrance arch, as in cursive italic writing, or a swinging horizontal stroke at the beginning of a word (this entrance is suitable for other letters as well). On an *m, n,* or *h* at the end of a word, you can pull the final downstroke outward for a swash effect; try to keep the counter shape smooth, and note the brush position shown in figure 5-11.

The *o* is usually made in two strokes, which helps to keep the letter compressed. But you may want to try a more casual one-stroke *o,* decreasing pressure as you come around and up on the right side (fig. 5-12). The one-stroke *o* tends to be wider.

The *q* can take a loop on the descender. Sometimes the capital-style *Q* is used at the lowercase x-height. Note the brush position for the tail on the *Q* (fig. 5-13).

The *r* and *s*

As with the *q,* the capital form *R* can be used instead of the lowercase *r* at the end of a word. In addition, the lowercase *r* has several variants (fig. 5-14).

The *s* too has several possible forms, two of which derive from sign-painting styles (see also chapter 4). An *s* that is compressed and has a lightweight stroke at center is constructed of three slightly curved and almost parallel diagonal strokes. Another form begins with a light upstroke and squares off at the baseline (fig. 5-15).

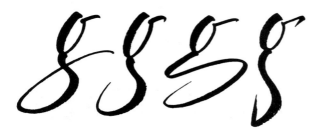

5-9. Variations on the roman-style *g* .

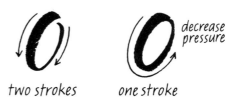

5-12. The *o* made in one or two strokes .

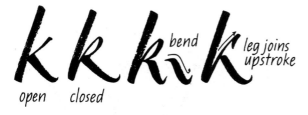

5-10. Forms of the *k* .

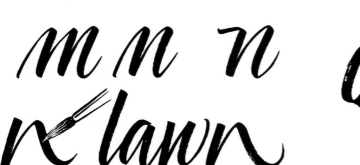

5-11. Entrances and final strokes: *n, m,* and *h* .

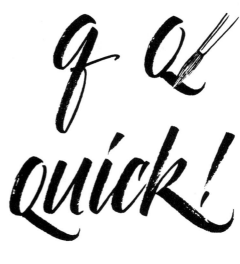

5-13. Alternative forms of *q.*

The *t*, *v*, *w*, *x*, *y*, and *z*

The *t* can have a bottom curve like the *u*, or it can terminate bluntly or with a flick. The stem can be extended but should not be as tall as the ascenders. The crossbar finishes straight (pull back into the stroke), in an upward curve, or with a downward flick (fig. 5-16).

The right side of the *v* and *w* can be an upward stroke that pushes inward slightly at the top to give a bit more weight and finish to the stroke; or it can be a downstroke made with lighter pressure. The right bottom point on the *w* can be rounded in a single stroke, or the final stroke can be thrown off in a flourish (fig. 5-17).

The lighter-weight diagonal on the *x* can be a downstroke or an upstroke with a flick finish. The *y* is based either on the *u* or the *v*. Its descender can be curved, looped, straight, bent, or made as an upward stroke, as with the *x* (fig. 5-18). The *z* can include a decorative crossbar, or it can have a descender in the cursive style, with several variations (fig. 5-19).

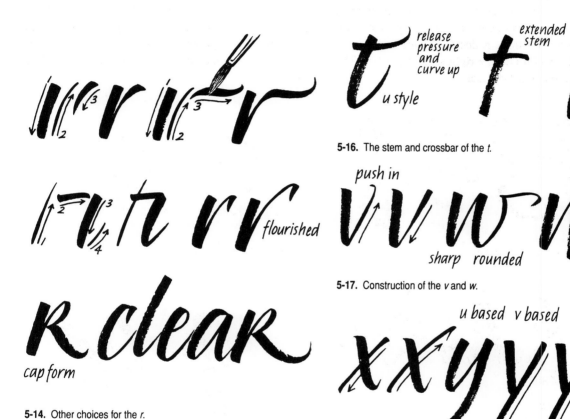

5-16. The stem and crossbar of the *t*.

5-14. Other choices for the *r*.

5-17. Construction of the *v* and *w*.

5-18. Alternatives for the *x* and *y*.

5-15. Two forms of the *s* based on sign-painting styles.

5-19. Two forms for the *z*, with variations.

Flourishes

Because of its fluidity, pointed-brush writing lends itself readily to flourishing. Flourishes should look natural and spontaneous, and the essential structure of a flourished letterform should remain evident.

Flourishes made with the pointed brush can be very lightweight and loose. Use the tip of the brush, and let your arm move freely. In many cases you may want to pause after finishing the body of the letter and then add the flourish as a separate stroke (be sure it looks like an integral part of the letter, not an afterthought). You may even decide to use a smaller or more delicate brush or try a two-finger grip that lets the brush move freely for these flourishes. Pay close attention to the counter shapes you are creating: they should be graceful and pleasing—avoid curls, spirals, and sags. Be careful too not to introduce inadvertently other letter shapes that will interfere with legibility.

Sometimes less is more: a single flourish can be very eloquent. At other times you may decide to be unrestrained and let the flourishing itself be the means of expression. Examples of flourished letters are shown in figure 5-20, but there are no exact rules or models. Similar movements of the brush can be applied to other letters, and you will certainly invent many more flourishes.

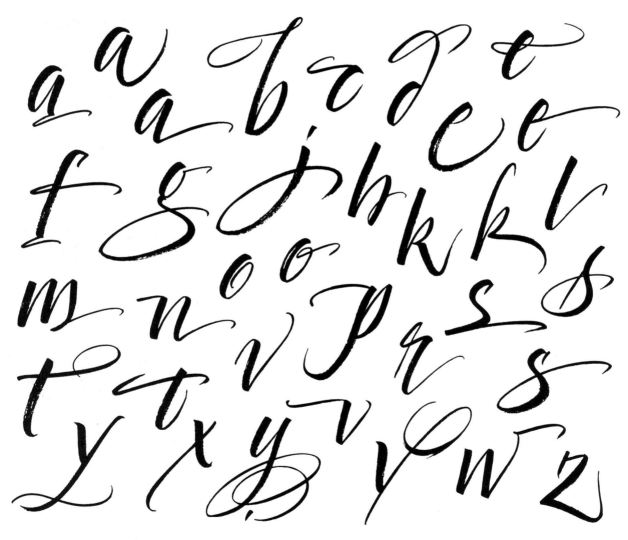

5-20. Some ideas for flourishing.

Capitals

Capitals, or majuscule letters, can be quite informal and loose, in keeping with the character of pointed-brush writing. The weight of the strokes will generally conform to the style of roman capitals, that is, thick stem strokes (downstrokes) and thinner horizontals. Some changes in weight distribution will result from the pointed brush, however, especially in the bowl shapes (fig. 5-21). Letter widths can be more uniform than with formal roman capitals, although the *B, E, F, P,* and *R* will look better if they remain relatively narrow.

Capitals with Minuscules

For text writing, aim to make capitals correspond in style and tone to your minuscule letters. For example, a flick finish on strokes is appropriate for caps if that is a feature of the minuscule script (fig. 5-22).

Basic caps for text will look less dominating on the page if they are shorter than twice the x-height. Brush positions for capitals are the same as those used for lowercase letters, that is, generally perpendicular to the letter stroke. On the bowl for the *B, D, P,* and *R,* begin with and maintain the brush position for horizontals. For the legs of *R* and *K* and the tail of *Q,* use the brush position for diagonals shown in figures 4-29 and 5-23.

Alternative Forms and Flourished Caps

In this chapter the model for basic capitals is a straightforward, unembellished alphabet (fig. 5-24). Some alternative forms are shown in figure 5-25. Flourished or swash caps can be relatively controlled or exaggerated and playful. Try some of the flourishes shown in figure 5-26: entrance flourishes, loops, extended or swelled legs, extended curves, extended baseline horizontals, and descenders or ascenders. Also explore freer, more decorative flourished capitals

that have more than one extension or swash but still hold the letterform (fig. 5-27). A highly embellished version derived from many copperplate forms appears in figure 5-28; note that the stem strokes are more solid and uniform in weight than their copperplate counterparts.

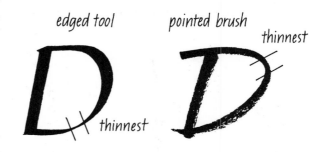

5-21. Comparing weight distribution on bowl shapes.

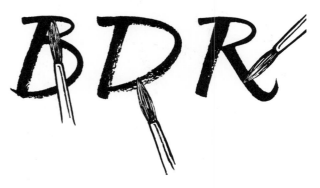

5-22. Relating capital and minuscule styles.

5-23. Brush positions for bowls (*B, D, P, R*) and for the leg of *R* (and *K*) and the tail of *Q.*

A B C D E F

G H I J K L

M N O P Q

R S T U V W

X Y & Z

5-24. Exemplar: basic capitals, or majuscules.

122 More Pointed-brush Lettering

ABBBDDD
EFF77GGG
GNJIIJJK
LMNOPPP
QRRRSST
JUVWYYZ

5-25. Some alternative capitals.

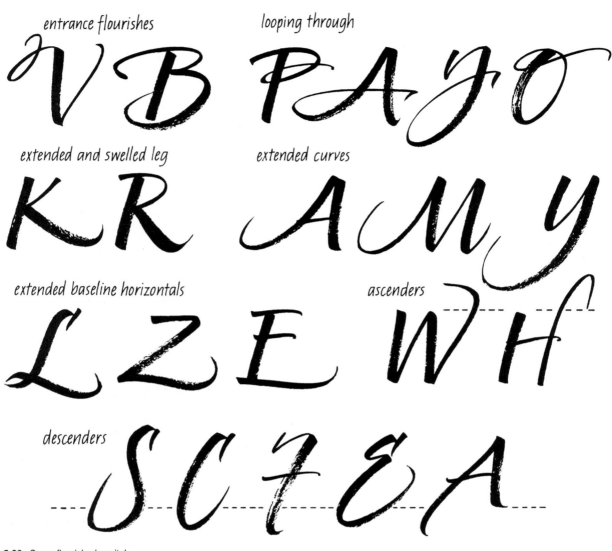

entrance flourishes looping through

extended and swelled leg extended curves

extended baseline horizontals ascenders

descenders

5-26. Some flourished capitals.

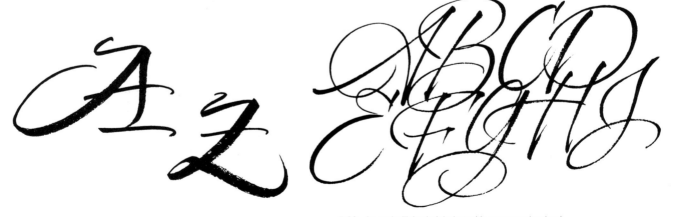

5-27. More decorative flourishes.

5-28. An embellished alphabet with some modernized copperplate forms.

Adapting Other Alphabets to the Pointed Brush

Most historical letterforms in Western writing are based on the edged tool—reed, quill, metal pen—and today we have versions made with the chisel-edged brush. You can also use the pointed brush to approximate an historical style, to reinterpret or modernize the script. Likewise, you can make pointed-brush versions of typefaces. Analyze the notable characteristics of any script or typeface; including its weight (the ratio of the thick strokes to the body height of the letters), the

relationship of thicks and thins, the width and slope of letters, the x-height, and the style of serifs. Then reproduce these features to recall that style (see figs. 5-29 through 5-35). Use pressure, brush position, and both the side and tip of the brush to achieve the desired results. You may not be able to replicate the edge angle, but try to match the alphabet's weight, shape, and other characteristics. Your pointed-brush version is likely to look more lively and spontaneous.

ABCDEFGHIJKLMNOPQRSTUVWXYZ

EVERY STEP IS ON THE PATH.

5-29. Pointed-brush rustics: all capitals, tall and compressed, high-waisted, with thin verticals, heavier horizontals and diagonals, and heavy slab serifs.

ABCDEFGHIJKLMNOPQRSTUVWXYZ

EVERY STEP IS ON THE PATH

5-30. Pointed-brush uncials: all capitals, short body height, round, and wide.

abcdefghijklmnopqrstuvwxyz

Every step is on the path.

5-31. Pointed-brush blackletter: square and angular, compact, diagonal base or foot serif.

abcdefghijklmnopqrstuvwxyz
ABCDEFGHIJKLMNOPQRSTUVWXYZ

Every step is on the path.

5-32. Pointed-brush Fenice (typeface): narrow, compact, oval shapes, strong contrast between thicks and thins, Bodoni-style modern typeface.

abcdefghijklmnopqrstuvwxyz
ABCDEFGHIJKLMNOPQRSTUVWXYZ

Every step is on the path.

5-33. Pointed-brush Hobo (typeface): bent verticals, nearly uniform heavy weight, sans serif, very short ascenders, no descenders, casual and playful.

abcdefghijklmnopqrstuvwxyz
ABCDEFGHIJKLMNOPQRSTUVWXYZ

Every step is on the path.

5-34. Pointed-brush Italia (typeface): uniform heavy weight, round, slab serifs, angled head serif, short ascenders and descenders.

abcdefg ghhijklmnopqrstuvwxyz ABCDEFGHCHI
JKLMNONOPQRSTUVWWXYZ

Every step is on the path.

5-35. Pointed brush Vivaldi (typeface): strong sloped italic, distinctive *a* bowl, short angled serifs, tall ascenders and descenders, flourished capitals.

Copperplate Script

After the invention of movable type, the scribe was no longer called upon to write out libraries of books by hand; handwriting was, however, still required for record keeping and personal correspondence. The secretarial hands of the fifteenth and sixteenth centuries were influenced by alphabets created with a process called copperplate engraving, originally a technique for printing illustrations in books, in which the letters were engraved on copper plates to create a prècise and flowing script. The gradually swelling lines of the engraver's burin could be replicated with a pointed, pressure-sensitive pen and came to replace those alphabets made with the broad-edged pen. By the eighteenth century, the writing masters who taught commercial script became highly competitive and produced elaborate exemplars by copperplate engraving to promote their art; many fine examples can be found in *The Universal Penman* by George Bickham, 1743 (fig. 5-36). Buried in these elaborate and decorative sample pages is the lowercase alphabet that was taught for handwriting.

Like its predecessor, italic (or chancery cursive), copperplate writing is based on a compressed oval but with a swelling of strokes and a high contrast between

Virtue and Arts are attained by frequent Practice & Perseverance.

Authors, Converſation, & Remarks

Academy

Foſter Lane

5-36. *Top:* Examples from *The Universal Penman* by George Bickham, 1743. *Bottom:* A handwritten example of copperplate from a writing exemplar book.

thick and thin parts of letters. Swelling and contrast result from pressure changes made with a flexible, pointed pen nib that is split; as pressure is applied, it splays to release more ink in a widening stroke (fig. 5-37). Handwritten commercial script, or copperplate, featured the greatest possible number of joins; compressed and strongly slanted letters; looped, spiraled, or knotted flourishes; and frequently looped ascenders and descenders.

This pressure-pen alphabet can be modernized and simplified for the pointed brush to make the script less formal. To imitate the delicate hairlines and precise rhythm of penmade copperplate, the brush should be held as vertically as possible to the paper. Weight changes in brush copperplate are made with pressure from the tip, rather than switching to the side of the brush. Slow continuous writing (pressure-and-release) is more appropriate than the broken-stroke method.

The basic *i*-stem stroke in the historical models has entrance and exit curves that are very thin and made with minimal pressure; pressure is applied coming into the stem to swell the stroke and then released to taper

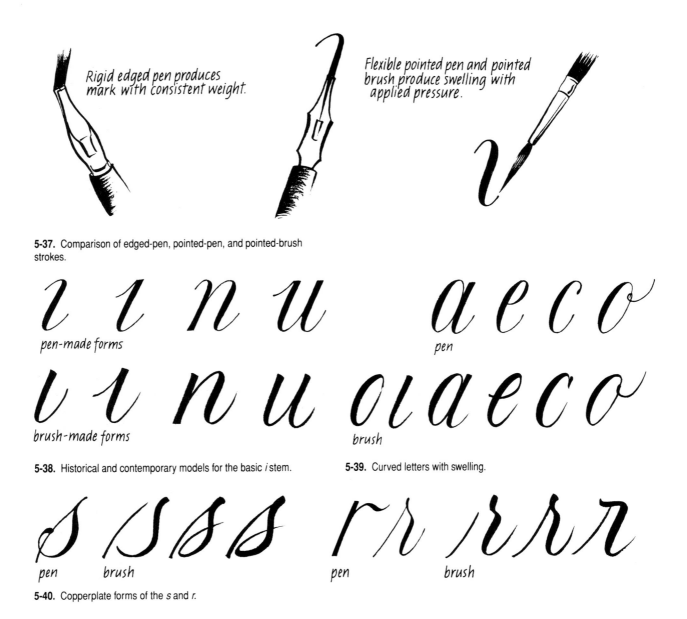

Rigid edged pen produces mark with consistent weight.

Flexible pointed pen and pointed brush produce swelling with applied pressure.

5-37. Comparison of edged-pen, pointed-pen, and pointed-brush strokes.

pen-made forms

brush-made forms

5-38. Historical and contemporary models for the basic *i* stem.

pen

brush

5-39. Curved letters with swelling.

pen brush

pen brush

5-40. Copperplate forms of the *s* and *r*.

128 More Pointed-brush Lettering

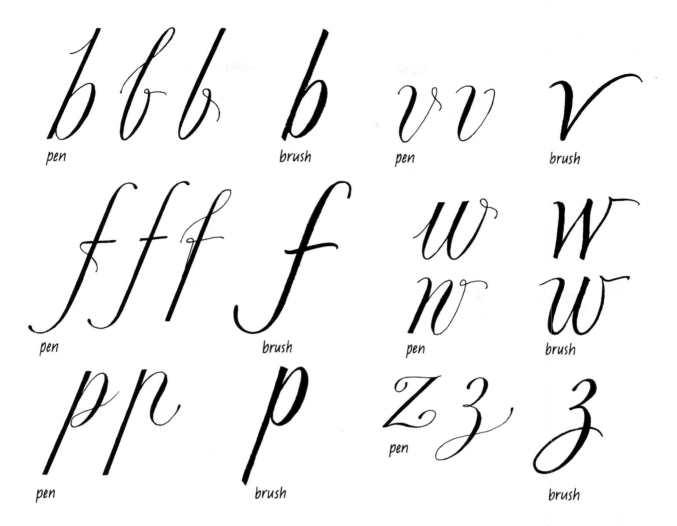

pen brush pen brush

pen brush pen brush

pen brush pen brush

5-41. Some historical copperplate letterforms and modernized brush versions.

the stroke before exiting. A modernized version can have a solid initial stroke by eliminating the entrance stroke on such letters as *i*, *n*, and *u* (fig. 5-38).

Letters with curved parts (*o*, *e*, *c*, *a*, *d*, *b*, *p*, *q*, and *g*) have a stress point in the middle of the curve, where the weight is heaviest, and a distinct lack of weight, or baldness, on the tops and bottoms of curves (fig. 5-39). Make the bowls of the letters by beginning at two o'clock on the clock face. The stroke travels left to define the top curve with a hairline, then down the left side of the bowl, with increasing pressure until you reach the stress point. Release pressure as you come down around the bottom curve in a hairline, moving up the right side to the starting point again. In letters in which the bowl is attached to a stem stroke (*a*, *b*, *d*, *g*, *p*, and *q*), there is noticeable branching or indentation at the top (and bottom). The *o* joins the next letter by tying a knot at two o'clock and connecting with an upward curve stroke.

The *s* has a lightweight slanted lead-in that is a reverse curve; the downstroke on the *s* can loop through the bowl to link to the next letter. A more radical change appears in the design of the *r*, which joins the preceding and following letters (fig. 5-40). Copperplate designs for *b*, *f*, *p*, *v*, *w*, and *z* can look old-fashioned and may not be immediately recognizable; they may work in certain situations, or the letterforms can be modernized (fig. 5-41). Figure 5-42 shows a

Brush Copperplate

abcdefghijk
lmnopqrrst
uvwwxyzz

ABCDEFG
HIJJKLMN
OPQRSTU
VWWXYZZ

5-42. Exemplar: brush copperplate script.

pointed-brush interpretation of copperplate script.

The separate bowl stroke that begins at the two-o'clock position on the *o*, *c*, *e*, and the *a*-bowl letters (*a*, *d*, *g*, *q*, plus *b* and *p*) is also used in sign-writers' commercial script alphabets. These are made with a showcard brush (round at the ferrule and blunt at the tip) that is paletted to be used like a pointed brush (fig. 5-43). The brush's shape allows less contrast between thick and thin strokes, which also serves to make the larger-scale showcard writing more readable at a distance. The copperplate *r* and *s*, as well as the *f* and *b*, have also been adapted to showcard scripts (fig. 5-44).

Eighteenth-century lettering artists invested most of their creativity in their capital letters. Some aspects of the capital forms are so far from the roman-based designs of the fourteenth century that they may seem foreign to our eye. Several techniques will help to romanize the script and give it a contemporary look for commercial and other purposes: make the hairline

showcard brush: round ferrule, flat tip paletted by twirling to make tip more pointed

5-43. Showcard brush for sign-writers' commercial scripts.

α a b c d e r

ʃʃ st A B E M

sample letters made with pointed showcard brush: not much contrast between thicks and thins

Rock 'n' Roll *Interested?*

Two Eggs, Bacon & Juice *Signwriters*

Hamburgers, Hotdogs *Script*

5-44. Showcard commercial script.

Karen Charatan

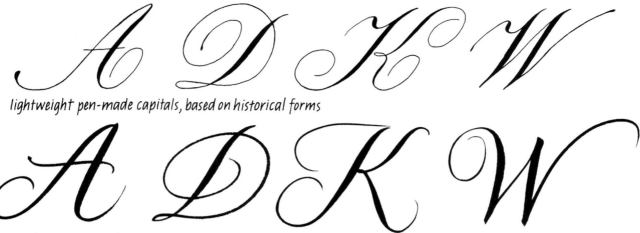

lightweight pen-made capitals, based on historical forms

brush-made capitals: more informal, retaining copperplate basis

5-45. Modernizing copperplate capitals.

strokes slightly heavier and less delicate; open up some of the condensed counters; eliminate crimped flourishes and ball endings (fig. 5-45). Many of the letters—*P*, *B*, *R*, *J*, *F*, *T*, *S*, *H*, *K*, *L*, and *D*—share a basic stem stroke (fig. 5-46). Some letters are unique to copperplate and work successfully in a modern pointed-brush script: a *Q* that resembles a *2*; an *E* like a backward *3*; and a *G*, *Y*, and *S* that are larger versions of the

lowercase forms (fig. 5-47). The copperplate lettering artists created exemplars of capitals with progressively more complex flourishes. Tracing the carefully prescribed cap flourishes until you can improvise and invent your own versions may be helpful. In fact, tracing a strong, simple, enlarged exemplar of copperplate capitals and lowercase (perhaps working first with a soft pencil and then with the pointed brush) is an

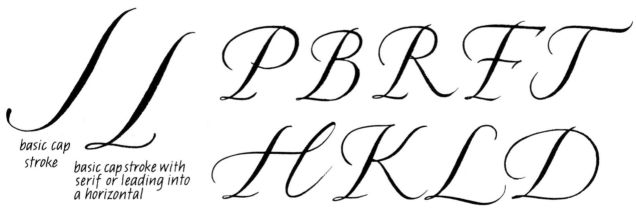

basic cap stroke *basic cap stroke with serif or leading into a horizontal*

5-46. A basic stem stroke common to many copperplate capitals.

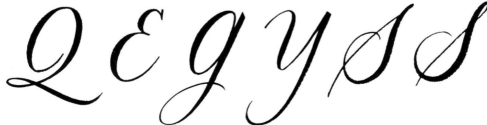

5-47. Other copperplate capital letterforms.

excellent way to teach your hand the new forms and weights if you have never done them with a pen.

Variations can be made by changing the height, width, or slope of the letters while keeping the essential copperplate characteristics. Copperplate can be drawn tall and compressed or very short and wide (or tall and wide, compressed and short), with almost no letter slope or with a very dramatic letter slope (fig. 5-48). Maintain the rhythm and style you have selected throughout the word, headline, or copy you are writing.

Copperplate (which also exists in slightly different forms as Spencerian, roundhand, or engrossing script) is an elegant hand best made with a pointed brush that has the longest bristles that you can comfortably handle. The tops of the vertical strokes may not be as clean as they would be if made with a pen; you may have to touch them up or draw in a corner. Writing slowly and with deliberation, you can produce a script that is almost as formal as that done with a metal pen, especially if you clean up the letters for reproduction; or you can write more quickly and informally but still maintain a casual kind of elegance (fig. 5-49).

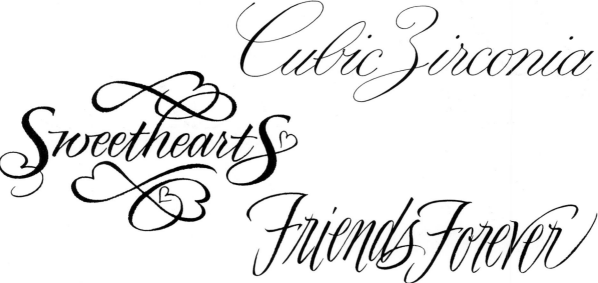

5-48. Variations on pointed-brush copperplate.

5-49. Contemporary applications of copperplate script.

Variations and Play

The range of variation possible with the pointed brush is as wide as one's imagination. Pointed-brush script is a contemporary style that can draw from historical sources but is not constrained by them. You can consciously manipulate or modify many aspects of the writing, including the structure and proportions of the letterforms, the contrast and weight of the strokes, the style of the serifs or connectors, the technique used to make basic strokes, the writing speed, the type of brush, the surface or substrate, the medium and its wetness, and the slope of the writing. Often simply playing, conversing with what is happening spontaneously on your paper, will lead you in new and unexpected directions that may provide the right solution to a design problem.

Simply changing the slope of your writing may create an appropriate effect. Most people write naturally with some forward slope, but you could try a stronger slope, vertical writing, or even a backslope (fig. 5-50).

Varying the slope within words can produce an intentionally childlike effect. While most lettering has parallel stem strokes or downstrokes, here the aim is to change the slope of adjacent letters. Note that nearby ascenders and descenders do *not* align. Varying slope and other factors, such as horizontal alignment, in a somewhat random way yields a naive or nonprofessional style (fig. 5-51).

You can vary the weight of the letters—from lightweight to extra bold—by adjusting pressure and/or how much of the side of the brush you use on the downstrokes. Theoretically, letter strokes could be as heavy or thick as the brush hairs are long. For making very heavy strokes, load the brush fully and use a juicy paint mix that will keep the bristles very flexible (fig. 5-52).

5-50. Changing the slope for variation.

5-51. Varying the slope within words.

Changing the body height or x-height also affects weight, by changing the ratio of the stroke width to its height. Lettering done at a one-to-four ratio of stem width to body height looks much heavier than lettering done at one-to-seven (fig. 5-53).

The ratio of the ascenders and descenders to the body height also affects the look of the writing. Exaggerating both the x-height and the ascenders and descenders can be a way to emphasize content or meaning (fig. 5-54).

Tapered strokes are made by releasing pressure as you finish a stroke, whether vertical or horizontal. A sharply tapered stem appears weak at the baseline, and so you probably will not use it for most of your writing, but this look sometimes is desirable in a specific context. It can be used, for example, for words that refer to the East because of the resemblance to Oriental character writing (fig. 5-55).

Introducing a slight curve as you taper the down-stroke ending makes the lettering look soft and deli-

light medium heavy

5-52. Varying weight by adjusting pressure and using the side of the brush (body height remains the same).

approximately 1:4 ratio stem width to body height *1:5 stem width to body height* *1:7 stem width to body height*

height height height

5-53. Varying weight by adjusting body height (the width of the strokes remains the same).

5-54. Varying the descender and ascender heights.

5-55. Tapering strokes by releasing pressure.

Variations and Play 135

cate. Bending the stem strokes makes the writing seem even more loose and flowing. Keep the curves subtle to hold the underlying structure of the letterforms (fig. 5-56).

A sans serif, or blunt-end, stroke without any connectors can look strong and be very readable. For crispness at the terminals, begin and conclude each stroke with a pause; you can even pull back into the stroke at the finish. Making the downstroke fast and pulling back into the stroke produces a bit more weight and darkness at the terminals. Use this technique to suggest an Optima-style swelling or a variegated look in the writing (fig. 5-57).

Adjust the relationship of thicks (downstrokes) and thins (upstrokes and connectors) to augment or diminish contrast in your writing. If you minimize the weight difference in thicks and thins, you will create a monoline effect; this technique works especially well with sans serif lettering (fig. 5-58).

Compressing both the letterforms and the interletter spaces produces density and blackness on the page, making a word or line read as a single design unit. Open up the interletter space by stretching the connectors to create airiness or a horizontal orientation (fig. 5-59).

5-56. Finishing strokes that taper and curve.

5-57. Sans serif writing; writing with swelled terminals.

5-58. Adjusting the weight of thicks and thins (and connectors).

5-59. Compression of letterforms and letter spaces; stretching connectors.

For more angular and compressed writing, make connecting or exit strokes close in to the letters, using an upward flicking motion. Minimize curves in the connectors and the letters themselves. You may even want to try a reverse curve for an interesting effect. In contrast, rounding the letterforms and the connectors may necessitate expanding the shapes. This type of writing is best done with an even pressure-and-release rhythm with few brush lifts (fig. 5-60).

Modifying the shape of bowls or curves consider- ably affects the appearance of the lettering (fig. 5-61). Be consistent throughout the alphabet when you introduce such changes.

A "bone" stroke can suggest Eastern brush writing. Its main feature in the stem stroke is a cinched waist with flaring at both ends. Two approaches are possible: carefully controlled pressure-release-pressure, or a downward flick (quick pressure release) joining a separate upward flick from the baseline (fig. 5-62).

5-60. Angular writing and rounded forms.

round

sharp

square

open bowl

elliptical

5-61. Modifying curves and bowl shapes.

pause

pull fast

pause
and flickin

flick
down

flick
up

5-62. "Bone" strokes or flared terminals can suggest Eastern writing.

Loops and overlaps also offer possibilities for varying your writing. Try to avoid "hot spots," which can result when two thick strokes intersect. They tend to rivet the viewer's eye to that denseness. Use lightweight strokes in the loops, and be aware of the many new counter shapes you are creating (fig. 5-63).

Change the usual pattern of heavy downstroke/light upstroke for variety and unpredictability. You might decide to establish a new pattern, such as adding one arbitrarily placed heavy stroke per letter, or you can let heavy strokes be more random. You can also experiment with letting counters or bowls fill in, thus adding solid patches to the writing (fig. 5-64).

Bouncing the letters in a word or line often adds liveliness and a sense of immediacy. Instead of using a baseline as your guide, try using a midline and moving the letters slightly up and down. For more movement, vary the size of the letters along with the bounce. Using a baseline and pulling some of the straight strokes below the line produces a rhythmic, controlled bounce (fig. 5-65).

Leaving a slight space between certain strokes of a letter that are normally joined gives a sense of lightness or sparkle to the writing. Similarly, a stencil style breaks apart many of the letter strokes. Also try using the side of the brush to create filled counter shapes in combination with a stencil style (fig. 5-66).

5-63. Loops and overlaps: avoid "hot spots," thick areas where heavy strokes cross.

5-64. Variations in weight distribution.

5-65. Bouncing, for more movement and liveliness.

up-and-down movement

stem strokes piercing baseline

variation in letter size

5-66. Spaced strokes and stencil styles.

Spiky, jagged lettering results from speed, flicked strokes, and exaggerated downstrokes. You might also try changing the orientation of your brush to the lettering, so that you are actually pushing instead of pulling the strokes. This technique will increase roughness and texture and produce thicker connectors. Using nonstandard brush holds or even writing with your nonpreferred hand—or with your eyes closed—may give results that you could not plan or predict, some of which may be usable or suggest new directions to pursue (fig. 5-67).

Multiple stroking can be used in a number of different ways to define the thick parts of calligraphic letters. Use a single, fine stroke for the thin parts (upstrokes) and a specific multiple (say, three) of fine strokes for the heavy parts (downstrokes); retain slight and equal spacing between the downstrokes. Or try using two different weights of stroke (different pressures) for the heavy parts. Triple stroking may involve making nonparallel, crisscrossing lines, which can be of different weights. Selectively filling in the resulting fragmented spaces will give you a pattern of triangular shapes inside the weighted letter "strokes" (fig. 5-68).

brush to left of writing, pushing strokes

writing with nonpreferred hand

loosely flopping the brush while pulling strokes

5-67. Experimenting with brush movements and brush holds to create different styles.

triple downstroke, single upstroke

double stroking, two weights of stroke

triple stroking, with crossed lines

5-68. Multiple stroking.

triple stroking, filling in spaces

Another variation of double stroking is to do the base writing in a lighter tone or color, with a lighter-weight, darker overlay of writing; the effect will be livelier if you do not try to copy precisely the letterforms underneath. You might also try using two different brushes in combination, one to make heavy strokes, and a smaller brush to make light strokes (fig. 5-69). Experiment with various colors, tones, and lines to create multiple-stroke compositions.

Exaggeration or repetition of a specific feature of a word or phrase may give the impact you want, or you can create emphasis by using contrast in size and form. Flourishing calls attention to a headline, especially in contrast with typeset text. Flourishing can be restrained and subtle or lavish, even overdone. A word or short phrase that is heavily flourished can have pizzazz, but too long a phrase may become an unreadable tangle (fig. 5-70).

lighter-tone base writing, with finer, darker overlay writing

using two brushes, one for heavier strokes, one for lighter strokes

5-69. Variations of multiple stroking.

5-70. Creating special effects using exaggeration, heavy flourishing, and contrast of size.

The characteristics of your own handwriting—whether it is small or large, round or angular, expanded or condensed, uneven or regular—may naturally be incorporated in your basic pointed-brush writing style. But your own handwriting and that of others can also be a resource for innovative forms and embellishments (fig. 5-71).

As with the edged brush, other variables to consider and exploit in pointed-brush lettering are speed, the writing medium, and the paper or surface. Greater speed or a dry mixture of paint will introduce more texture to the writing. A rougher paper surface will also give more texture. Conversely, you can obtain more solid strokes with crisper edges by writing slowly, by using a wet mixture of paint (or using ink), and by using a smooth-surface paper (such as a coated paper, a hot-press watercolor paper, or Mylar or work-

able acetate). An unsized or absorbent paper will cause the medium to bleed or feather and thereby look wet (fig. 5-72).

Using freely made brush letters in conjunction with drawn letters or type can produce lighthearted or even zany effects (a ransom-note style). A typeset capital letter overlaid with a loose pointed-brush capital uses contrast of form to make a striking decorative initial (fig. 5-73).

Pointed-brush writing in blocks of text will have a particular rhythm, pattern, and texture, depending on the choices you make: compressed or expanded, round or angular, lightweight or bold, and the like. Text writing will display more consistency and regularity and require fewer decisions about the design of individual letters (fig. 5-74).

5-71. Handwriting as a resource for pointed-brush script.

wet and dry

slow and fast

charcoal paper, coated paper

paper towel, toilet paper

5-72. Wetness, speed, and surface variations.

5-73. Combining drawn or typeset letters with pointed-brush letters.

You may want to experiment with specialty brushes, that is, unusual handmade brushes or brushes ordinarily used for other purposes (fig. 5-75). Brushmaker Keith Lebenzon crafts beautiful natural-hair brushes with unique carved bamboo handles. Some Oriental brushes, as well as the Lebenzon brushes, have very long hairs that taper to a delicate point. It may be harder to produce neat and controlled letters with these brushes, but they are perfect for certain effects .

The "Miracle Wedge" is a craft brush with a trian-gular ferrule; it has a very full and fat base that tapers abruptly to the tip. Use it for dramatic writing with strong contrast between thicks and thins.

The dagger striper has a flat ferrule and a diagonal cut across the tip. Use the full width of the brush for downstrokes and just the point for upstrokes. This brush will let you make large letters, for signs or banners, with great regularity and strong contrast of thicks and thins. Be on the lookout for other nonstandard brushes to increase your repertoire of styles and effects.

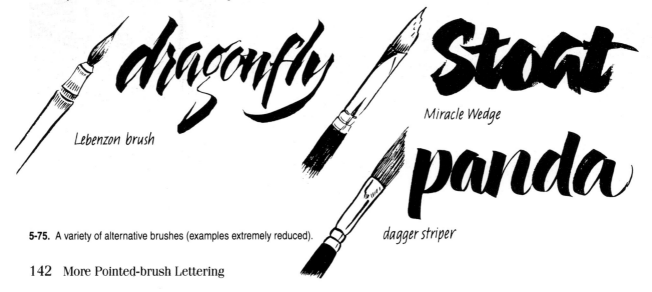

5-74. Rhythm and texture in blocks of text writing.

5-75. A variety of alternative brushes (examples extremely reduced).

6. Many Uses, Many Artists

Other Media

Acrylics

While gouache, watercolor, and ink are the standard media for brush lettering, acrylic paints are versatile and offer many possibilities. Acrylics can be thinned and used as a transparent medium like watercolors (thin them with acrylic medium rather than water), or they can be used full strength in a heavier application for more opacity. It is even possible to build up a textural surface with the paint, allowing the brush marks to show. Acrylics are waterproof when dry, yet they clean up easily with water and have no fumes. They dry fast.

Acrylics are available in a wide array of colors as well as some specialty lines such as metallic, iridescent, and interference colors. Most colors are sold in tubes or jars; the jar colors are more fluid and generally make a better writing medium. Acrylic medium for thinning has either a gloss or mat finish (you can also mix them). Gel medium works for impasto painting or as a paper glue for collage, but it is not a good brush-writing medium. You can also purchase acrylic inks, which are thin and slippery. Some manufacturers make acrylic gouaches or mat acrylics that are opaque, dry to a flat finish, and are waterproof and durable.

Acrylics can be used on paper, fabric, or even Plexiglas and other surfaces. If used on fabric, they are washable, but the paint must be thin enough to penetrate the fabric, or it will crack and chip off. Acrylics do not require heat setting on fabrics.

Some artists report that acrylics have a slippery feel, making control of the brush mark and the amount of paint difficult. Certain brands or colors have bulky fillers that make it hard to obtain a flat, even coating of paint, and some colors seem thin and transparent. Writing with a pointed brush is more difficult with acrylics because of the viscosity of the medium; they are easier to use with an edged brush.

Acrylics are harder on brushes than watercolor or gouache is because any paint that dries in the brush is hard to remove; it can damage the brush and cause the bristles to splay. We recommend reserving some of your brushes for acrylics only. Keep the brushes submerged in water while you work (preferably suspended so the bristles do not bend); while this practice is not good for the brushes (the glue holding the bristles in place may break down), it will prevent paint from drying in them.

Because acrylic paint dries fast and does not reconstitute with water, you may not want to premix a large amount. Instead you can use a glass plate or palette paper to mix as you go. Retardants can be added to slow the drying time.

Water-based Silkscreen

Water-based silkscreen is a printmaking process that is growing in popularity. Its greatest advantage for the lettering artist is that what you write is what you get; most other printing processes produce a reversed image. With the silkscreen process, you can make multiple prints in many colors, from editioned fine-art prints to greeting cards to T-shirts. You can work directly on the screen with the brush to create your writing and images, or you can work in black-and-white on paper and use photographic methods to reproduce your writing in color.

6-1. Water-based silkscreen lets you work directly on the screen or from lettering done on paper to make multiple copies in color. A rubber-edged squeegee pushes the ink through the screen stencil onto your paper; the image is not reversed.

The screen is a polyester (formerly silk) mesh that is attached to a wood frame, which is then hinged to a base; you can buy screens commercially or make your own. An acrylic block-out (masking) medium and a writing fluid, or a photographic emulsion, are used on the screen to create stencils. As the acrylic silkscreen ink is pulled across the screen with a rubber-edged squeegee, it passes through the unmasked openings (the letters) onto the paper positioned underneath (fig. 6-1). For each color you will need a new stencil, but the previous stencil can be easily removed and the screen used again. The solvents required are trisodium phosphate, a strong detergent sold in hardware stores, and household bleach, which do not produce the heavy fumes associated with solvents for oil-based inks, making the process feasible in a home studio or kitchen.

Other Surfaces

The brush is the tool of choice for writing on hard, uneven, or vertical surfaces, just as it was in Roman times, when lettering artists did their preliminary lettering with brush on stone or painted public notices on walls. For permanence and durability, oil-based enamel paint is recommended for work on outdoor windows, wood signs, walls, or metal. Stores that carry sign-painters' supplies will stock brands of paint that are specially formulated for these applications.

Oil-based paint is very viscous and handles differently from water-based paints. You will need to work with a long-bristled brush that holds a lot of paint. Avoid writing alphabets that have very fine thin strokes or serifs; enamel paints do not easily produce crisp thin lines, and fine lines may not be legible at a distance. Choose bold alphabets with less thick-thin contrast and sign-painters' alphabets.

Smaller sign lettering is traditionally done with quill brushes, which are long, full, and straight across the tip but have a round ferrule so they can be paletted as an edged or pointed brush.

When working on glass, presketch your guidelines or design onto the glass with a grease pencil, or tape a paper sketch to the back of the glass. To write on large surfaces or surfaces that are hard to reach, such as a wall, you can make a perforated paper pattern that you can pounce with chalk to transfer the design (fig. 6-3). You can make guidelines by coating a string with

Marilyn Reaves

6-2. Five-color photo-silkscreen print. The original pointed-brush writing was done with black ink on paper.

pattern

pounce bag and pounce wheel

6-3. Transfer a pattern of your lettering onto a vertical surface by tracing the outline with a pounce wheel and then dabbing a chalk-filled pounce bag along the perforated lines.

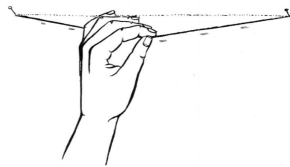

6-4. Snap a taut chalk-covered string against a vertical surface to make guidelines.

chalk and snapping the taut string against a large surface (fig. 6-4). When lettering on a vertical surface, you can use a mahl stick to steady your hand and keep it off the writing surface (fig. 6-5). Pull the stick downward to let your writing hand make downstrokes with the brush.

The same paint and tools will work on metal (such as a car door) and on Plexiglas. Wood signs also call for enamel paint, but the wood surface should be presealed. On all these surfaces, the paint can be wiped off with a little paint thinner or turpentine if you make a mistake. If you need to thin the paint to produce more delicate letters, you can use a smaller, pointed brush to layer on another coat of enamel paint.

You can use many other surfaces for brush lettering or decoration: plaster or painted walls, stone surfaces, brick, and Mylar or other plastics, to name a few. Clay offers many exciting possibilities: tiles, plates, and bowls, for example (fig. 6-6). Lettering can be applied in similar ways, using slips (liquefied clay) or glazes. Pointed-brush styles lend themselves well to ceramics and can recall Eastern calligraphy, but you can also use edged-brush writing for more contemporary, "Westernized" results.

Different clay bodies, glazes, and firing techniques will yield very different (and unpredictable) results. It is difficult to see what you are doing with some colors of slips or glazes. Hairlines may become wider during firing, and hotter temperatures in the kiln may obliterate some marks.

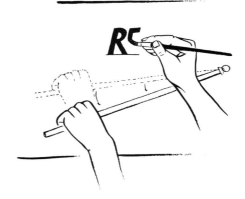

6-5. Use a mahl stick to support your writing hand against a vertical surface and to avoid touching the wet paint.

Bettye Lou Bennett

6-6. Brush lettering on tile mounted on weathered barn wood.

Brush for Reproduction

Getting Started with Thumbnails

Whether your lettering is for your own design, such as a card or flyer, or is to be a part of someone else's design—perhaps a headline for an advertisement—a good approach is to begin with small idea sketches, called *thumbnails* (fig. 6-7). These small sketches should be very quick and loose, indicating the shape of the space, the placement of the different elements (illustration, lettering, type, photo), the focal point,

and other general considerations. Include the overall profile of the lettering: its size, weight, body height and ascender/descender proportions, along with the feasibility of flourishes. After selecting your best ideas, you may want to expand them into larger, more detailed drawings, called *roughs*.

If you are fitting your lettering into someone else's design, request a rough layout sketch from them and have them indicate where the lettering should go (fig. 6-8). How they sketch in the lettering will give you

6-7. Thumbnails are small, quick sketches used to illustrate layout ideas.

important information on what they want, sometimes more than they can describe verbally. Also, knowing the finished size of the lettering is critical. If the lettering is to be used for more than one application and is to appear at different sizes, you may need to provide a version for extreme reduction or enlargement. If the lettering has multiple uses, as in a logo, the design and drawing stage will be much more extensive, as you explore how the lettering works at different sizes and in different formats.

Choosing a Style

Once your essential format has been established, you can focus on the lettering itself and begin to explore the specifics of style. Even if you have in mind a style you have previously used or the client has chosen a style from your portfolio, do not limit yourself too soon. The particular words and letters in this assignment are unique and may need a variation or even a fresh approach. Keep a file on lettering, typography, and even brush illustrations that inspire you. Examples in graphic design magazines and annuals, calligraphy periodicals and newsletters, lettering and general art books, greeting cards, and brochures may suggest new ideas or techniques or just a new perspective.

Try to work experimentally with the letters at this stage, writing quickly, perhaps even illegibly; sometimes freedom leads to new ideas. Play with different tools and paper surfaces, which may dictate a new style or texture. Remember the options of expanding or condensing, modifying height or weight, changing the rhythm or bouncing the letterforms, connecting or not connecting the letters, varying letter slope, adding

expressive flourishes, or even outlining or applying textures by using the brushmade letters as an underlay (fig. 6-9); see also "Variations and Play" in chapters 3 and 5. A drop shadow can be roughly sketched or created with two copies of the same lettering, one on translucent drafting vellum, slightly offset from the other. If your rough drawing provided you with the format for the letters (cap-to-lowercase relationships, design of ascenders/descenders) you may want to use

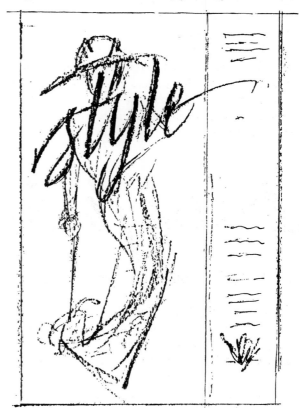

6-8. Get a rough layout sketch from the client and use it as an underlay if necessary.

A. *style*

B. *style*

C. *style*

D. *style*

E. *style*

F. *style*

G. *style*

H. *style*

I. *style*

J. *style*

K. *style*

L. *style*

M. *style*

6-9. Style experiment sheet. Mark your favorite(s) or the client's choices and make notes or comments. Labeling each version helps in phone conversations.

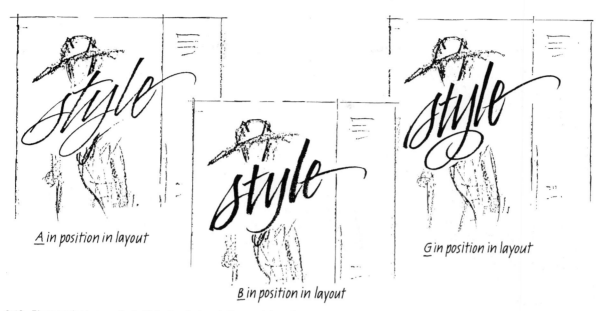

<u>A</u> in position in layout

<u>B</u> in position in layout

<u>C</u> in position in layout

6-10. Place each of your selected lettering designs in the rough layout to see how it works with the other elements.

it as an underlay while you work, after enlarging or reducing it on a copier to fit the tool you are comfortable using.

Make numerous sketches (fig. 6-9). Before you perfect the letterforms in any one style, narrow your choices to the two or three best designs, and fit them (with the aid of a zoom-lens photocopier) into the layout, to see how they work (fig. 6-10). Then make your final selection and begin the process of refining and touching up.

Sometimes a client will simply want you to explore the possibilities of a word or phrase; he or she may want to begin with some visuals from you before finalizing a design. Depending on the particular client, you may want to limit the choices or present a wide range of options (fig. 6-11). Be aware that some clients, especially committees, try to pick and choose among letters to create an amalgam (a danger to design!). Present only those choices that you want to continue exploring.

Book title: final version combines elements from two examples.

6-11. You can try a wide variety of styles or ideas for initial caps; sometimes a job requires extensive style exploration.

Paste-up by Hand

It is not necessary to write the word or headline you are lettering over and over again until it is perfect. You can splice together the best of several attempts by applying some kind of repositionable adhesive on the back, such as hot wax, rubber cement, or spray glue. Or, at the early stages, just tape pieces into position with white artist's tape, clear removable tape, or other low-tack tape (fig. 6-12). Before you start cutting up the artwork, make a photocopy in case you make a mistake or lose a small piece; continue making these backup copies as you work. If the paper is very heavy, as rough watercolor paper is, you might need to use a photocopy for splicing, because heavy paper can create shadow lines along the cuts when it is copied.

At this stage, you can also change the size of certain letters by using the zoom lens of a photocopier. If the whole word or series of words slopes up or down slightly or if the letter spacing is uneven, you can correct this by cutting and repositioning the letters. After this initial splicing of the best letters, you will need a

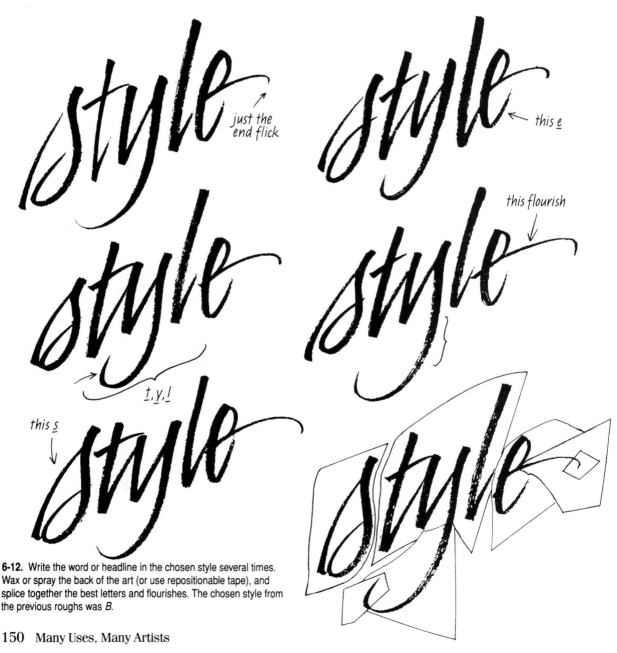

6-12. Write the word or headline in the chosen style several times. Wax or spray the back of the art (or use repositionable tape), and splice together the best letters and flourishes. The chosen style from the previous roughs was *B*.

fresh, dark photocopy that is larger than what the finished reproduction size will be (fig. 6-13). When selecting the size of this copy, consider the size that will be comfortable to work with, the size of the tool you will use for further refinement, and the final size of the lettering. Trim the paper, and attach the lettering to white cover stock (stiff paper) or light bristol board that is slightly bigger than the lettering, so you can rotate it and move it for drawing and touch-up. Be sure no loose edges or corners are sticking up, as they may pull up and create shadows or cause small pieces to fall off. It helps to round off all sharp paper edges.

Drawing and Touch-up by Hand

You can alter and improve the letterforms on your working photocopy with the drawing tool of your choice. Use it to strengthen light areas, beef up weak connecting strokes, equalize weights of the strokes, even up the texture on the outside or inside of the strokes, make edges crisp, reform flourishes and counter shapes, or make serifs or terminals match (fig. 6-14).

Work with dark black waterproof ink and a fine felt-tip pen, pointed nib, technical pen (size 0 or smaller), or small pointed brush (size 00 works well). Use a sharp X-Acto blade for cutting (fig. 6-15). Make corrections with a small brush and thickened FW white ink, or use photocopy "white out" or fairly thick

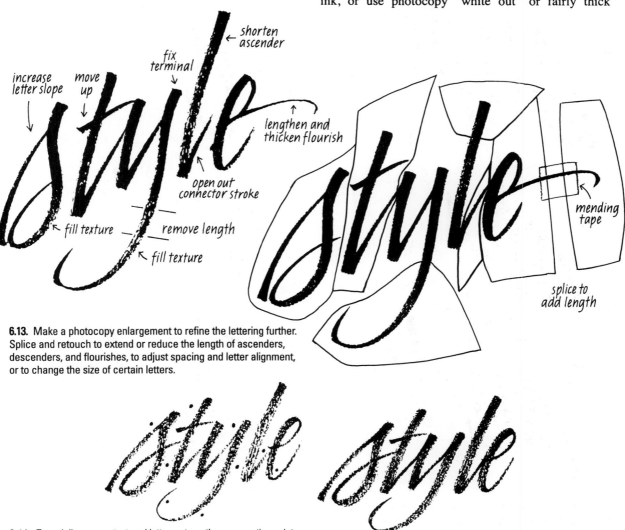

6.13. Make a photocopy enlargement to refine the lettering further. Splice and retouch to extend or reduce the length of ascenders, descenders, and flourishes, to adjust spacing and letter alignment, or to change the size of certain letters.

6-14. Especially on very textured letters, strengthen connective points and parts of letters that are critical for legibility.

gouache. To strengthen or increase the weight of textured letters, you will need to imitate the mark's texture, especially along the edges of strokes. The tool you use must be small enough to draw the little dots and bumps so they blend in visually.

You can increase the weight of a stroke while retaining its "natural" edge by slicing the stroke in half, moving the two halves apart, and filling in the middle (fig. 6-16). You can also extend letter parts by slicing, moving pieces up or down, and filling in gaps. If you are extending ascenders or descenders, fill the gaps by drawing with pen-and-ink, or make a photocopy of the stroke and fit it in the gap (see fig. 6-13). You can borrow edges from the other letters using photocopies or previous roughs. A small piece of transparent tape on top of the gaps to be filled in will help you work over cut edges of paper. This kind of repair work will be less noticeable when you reduce the copy to

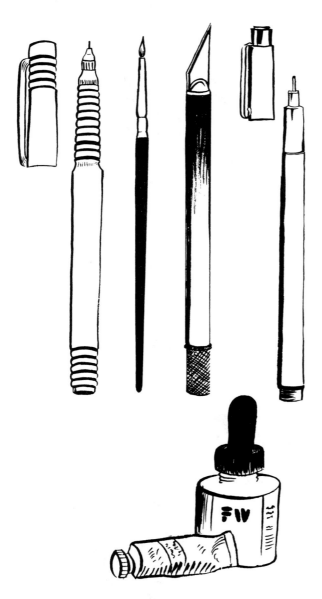

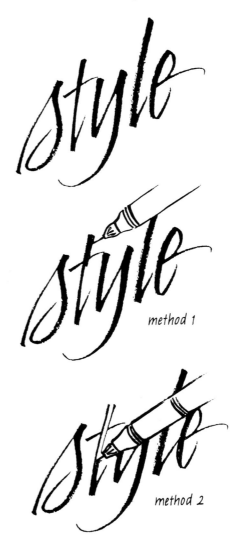

6-16. You can increase the weight of a letter in one of two ways. Method 1: Draw on the outside of the letter with the technical pen, extending the edge with the same texture. Method 2: Slice the stroke down its center. Separate the two halves, leaving a gap in the middle of the stroke. Cover the splice with mending tape, and fill in the gap by drawing with a technical pen, imitating the texture of the stroke.

6-15. Tools for reproduction: a technical pen, a no. 00 brush, an X-Acto blade, and a fine-point felt-tip pen; white FW ink and white gouache.

its final size. Remember that for any casual, textured styles, you run the risk of ruining the spontaneous and natural look of the lettering with too much touch-up and overdrawing.

To smooth out the letterforms of a clean-edged style, use a technical pen or fine felt-tip pen and either draw the edges freehand; use a bridge to brace and steady your hand; or use French curves or templates to make precise curves. You will need to move the French curve or oval template along the curve to match sec-tions, which takes some practice. The X-Acto blade becomes a handy clean-up tool for some of these styles, and you can cut against a template for a smoother edge. Use the X-Acto and ruler to square off terminals; sometimes cutting against the slight curve of a template edge gives the terminal a less mechanical-looking edge (fig. 6-17).

If your lettering will be scanned, make a high-quality clean photocopy larger than the final size. You can make appropriate reductions on the computer.

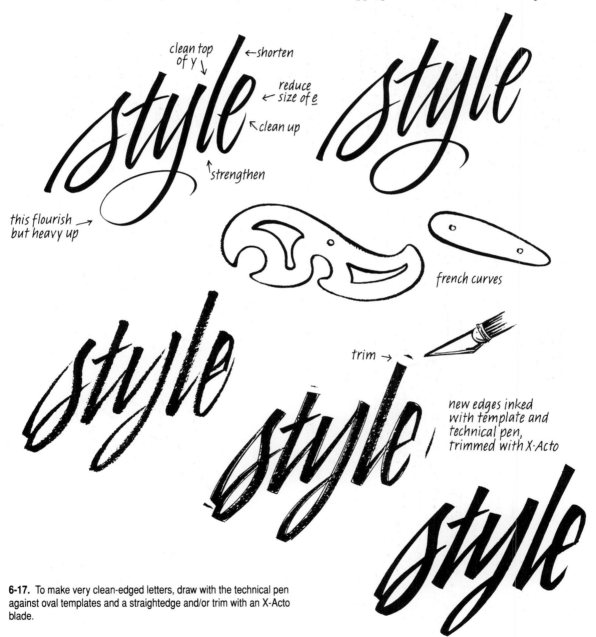

6-17. To make very clean-edged letters, draw with the technical pen against oval templates and a straightedge and/or trim with an X-Acto blade.

Brush Lettering and the Computer

You can take your final brush lettering to a copy center and get a photocopy, or you can have the artwork scanned and stored in the computer as an art file (tif, gif, jpg). You can then save it onto a CD or have it printed out on an inkjet printer or a laser printer. The quality of this printout will depend on the type of scanner used, the skill of the person using the software to scan and print, the quality of the printer, and the output resolution (dpi, or dots per inch). The higher the resolution, the less you will notice with the naked eye that the image is composed of tiny squares of black. Low resolution results in a pixilated or stair-stepped edge. The digital image will never be as a true copy of the original as you would get with a good photocopy.

The scan of the artwork is pulled into a photographic program (such as Adobe Photoshop) as if it were a drawing or photograph. The background is included in the size (dots or pixels per inch) of the image, so crop close to the letterforms. If you are familiar with the photo software, you can use the palette to continue building up or smoothing out the letters with the brush and the eraser tools, just as you would with a technical pen and white ink. You can also take letters or sections of letters and copy, cut, and paste them to change or alter them, just as you would with a photocopy and an X-Acto knife. Each pasted element sits on its own layer, so you can use the program's layers palette and continue to manipulate each element (shorten flourishes or ascenders, re-size letters, etc.). When you are done, you can flatten the final image into one layer. The computer program has effects you can apply to your artwork, such as color, shadows, embossed effects, texture, and many others.

If the lettering has a lot of internal texture, or varying shades of black (grays), then place it in the layout as if it were a photo, or halftone. If the lettering is simple black and white (line art), you can outline it with the pointed pen tool (tools for this process are in the software's tool palette), or you can use an outlining program such as Adobe Streamline. Now the art is in outline form, with only as many points as it takes to outline the letters in the word. Each point has grabber bars (called Bezier bars or Bezier control points) that let you change the curve of the line between each point. You can continue to refine your letters by manipulating these curves or by subtracting or adding points as needed. A rough-edged letter will contain more points than a smooth-edged letter. This outline file is easier to manage than the flat art file (tif, jpg) and also allows you to color, outline, inline, reverse, make drop shadows, apply effects, and layer with other art in the layout or illustration program.

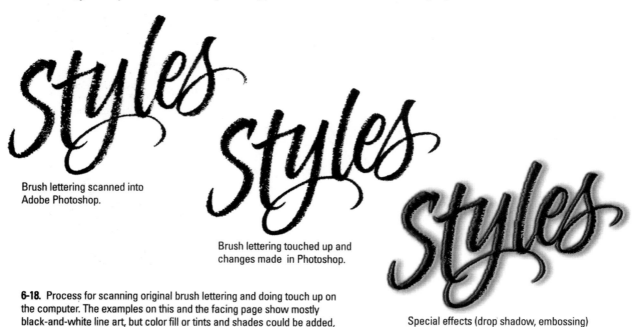

Brush lettering scanned into Adobe Photoshop.

Brush lettering touched up and changes made in Photoshop.

6-18. Process for scanning original brush lettering and doing touch up on the computer. The examples on this and the facing page show mostly black-and-white line art, but color fill or tints and shades could be added, or colored artwork could be scanned.

Special effects (drop shadow, embossing) added in Photoshop.

Despite the wide availability of calligraphic computer fonts, there is still call for lettered titles, headlines, logo identities, taglines, and writing done by the human hand. However, it is important to know how to present your lettering digitally for these purposes, because much of today's printed material is assembled in computer layout programs. The computer also allows us to create custom fonts for specific uses—a business, a campaign, or a single project.

Lettering outline, not filled in. The outline is made up of points, with Bézier bars reflecting changes in direction of the line. Rough outlines have many points.

Detail showing points.

Subtracting points smoothes out the line. This example shows the outline with many points subtracted.

Detail showing fewer points and smoother outline.

Smoothed outline filled in with black in Adobe Illustrator.

Smoothed outline filled in with gradient shade, outlined in black; stroke weight .75 point, layer with transparent version for drop shadow effect.

Brush Lettering Today

Brush lettering today is a lively art with many dimensions and many applications. In an age where anyone with a personal computer can manipulate letterforms or create layouts with multiple type styles, the uniqueness, personality, and expressiveness of hand lettering is even more apparent and appealing. Presented here are examples of Western brush lettering done by some of the most accomplished lettering artists working in the field. The illustrations range from informal personal work to commercial logotypes and product names to fine-art pieces; they show a tremendous variety of styles and means of individual expression.

Both the chisel-edged brush and the pointed brush are in evidence. Highly refined or polished lettering may use drawing techniques and drafting tools to achieve the final effect; in other examples the lettering is direct and unretouched. In some cases the hand lettering is used in close conjunction with type. We have also included examples of the brush used for drawing, for borders, and for decorative purposes. Some of the styles exhibited here are intentionally naive, to convey a particular mood or feel.

The work ranges from clear and finely crafted calligraphic letterforms to gestural or abstract brushstrokes that may not be immediately legible. In all cases we believe the work is interesting, well executed, and appropriate to its purpose, and we thank the many outstanding artists who have contributed to these pages.

A. Iskra Johnson
B. Carl Rohrs
C. Fran Sloan
D. Iskra Johnson

A

B

C

D

BARYSHNIKOV

Gifts

Hacienda

Starlight Celebration

photography

Inspiring American Creativity
and Inventiveness

Let's Celebrate!

A. Brenda Walton
B. Nancy Stutman
C. Nancy Jang
D. Sarah Frederking
E. Rene Schall
F. Fran Sloan
G. Sherry Bringham
H. Karen Charatan

E

A

F

B

G

C

Karen Charatan
75 Upper Saddle River Road • Montvale, NJ • 07645
201-930-9608 FAX 201-930-1295

H

D

A. William Stewart
B. Sarah Frederking
C. Prindi Flug
D. Rene Schall
E. Nancy Stutman
F. Marilyn Reaves
G. Kathy McNicholas

A

D

B

Gentle Yoga
WITH NAOMI

E

C

MULTI·PURPOSE
Letterlines
GUIDELINES

F

interloper
DESIGNS FOR MEN

G

A. Jocelyn Curry
B. William Stewart
C. Carl Rohrs

A B C D E F G H I

J K L M N O P Q R

S T U V W X Y Z

A

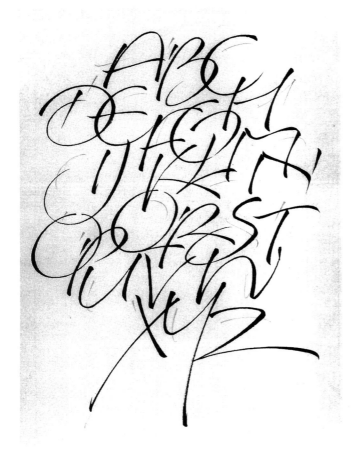

B

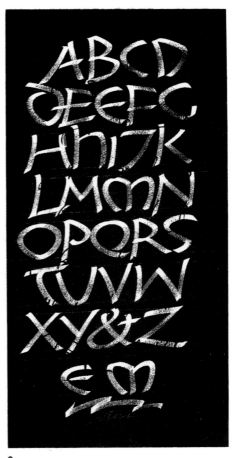

C

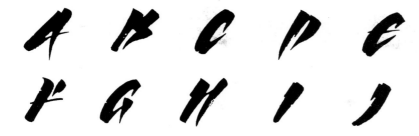

A. Teri Kahan Stumpf
B. Carl Rohrs
C. William Stewart

A

B

C

A. Katharine Wolff
B. Eliza Schulte
C. Marilyn Reaves

ABC
SPQR
Z

A

1 2 3 4
5 6 7 8

1 2 3 4 5
6 7 8 9 10

B

C

Monarch

A

Prest!

B

SILVER FOX

E

Agriculture 農

C

♡ *Healthy Lifestyles*

F

☆ HAPPY ☆ CHANUKAH

D

We are kind-hearted & hospitable, cheerful & well-liked.

G

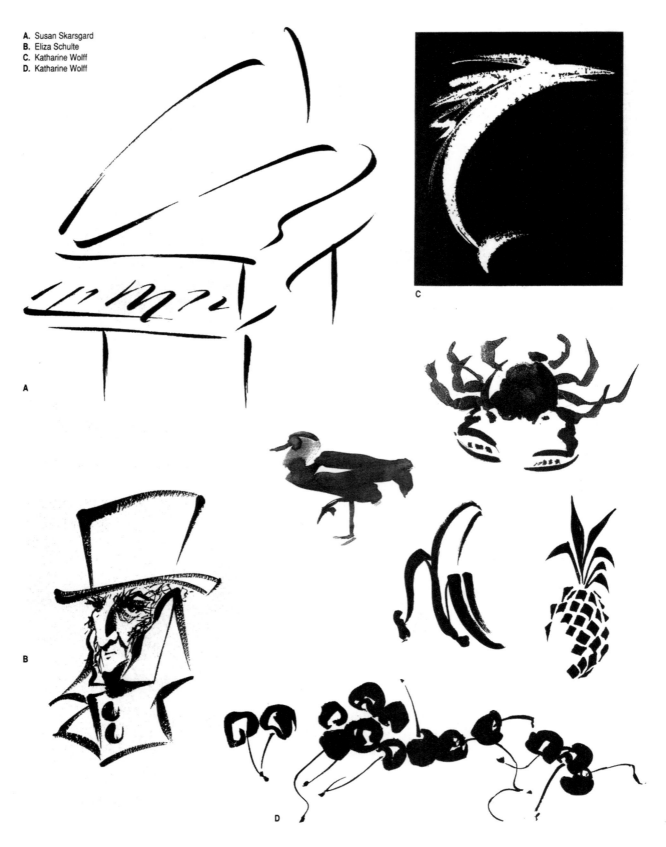

A. Susan Skarsgard
B. Eliza Schulte
C. Katharine Wolff
D. Katharine Wolff

stephen king's graveyard shift

A

make a
joyful noise
unto
the Lord...

PSALM 100

B

Albanese
Renk

C

New
&
Improved

D

depression

E

A. Georgia Deaver
B. Lisa Rogers
C. Jane Dill
D. Sara Frederking
E. Eliza Schulte
F. Katharine Wolff
G. Kathy McNicholas
H. Timothy Botts, from *Doorposts* (Tyndale House, 1986), gouache on Arches watercolor paper

THE OCEAN CLUB

F

Primate

G

Since Jesus himself has now been through suffering and temptation he knows what it is like when we suffer and are tempted, and he is wonderfully able to help us. HEBREWS 2:18

H

A. Louise Grunewald, greeting card for Leanin' Tree
B. Pam Paulsrud, "Jazz Fantasia," gouache and watercolor, edged brush, 20 x 30"
C. Dick Beasley, "Contrasts," oil on gessoed canvas, 44 x 44"

A

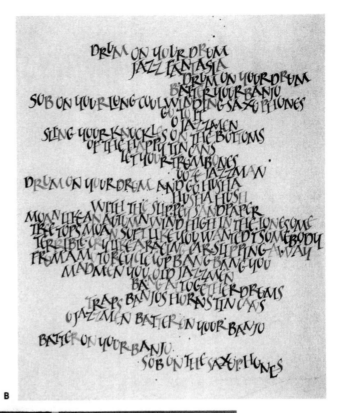

B

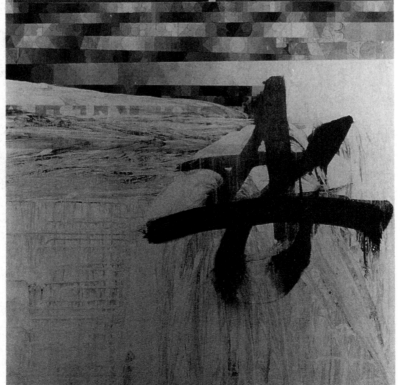

C

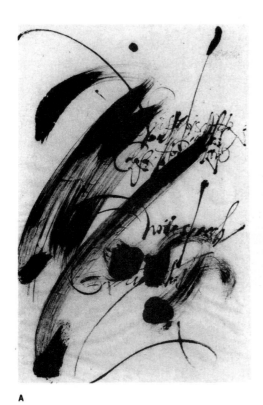

A

A. Rose Folsom, "Hannah's Dance," ink on Japanese paper, 24 x 39"
B. Teri Kahan Stumpf, "Huna Magic II," watercolor, 13 x 20"
C. MJ Gelin, "Alphabet," watercolor, 6 x 3"
D. Jenny Hunter Groat, "Other Stars, Other Voices," sumi ink, acrylic, gouache, watercolor on rag board, 30 x 40"

C

B

D

A. Jenny Hunter Groat, Ralph Waldo Emerson quotation
B. Richard Stumpf, "Puamana Seabreeze," multimedia fan, 30 x 18"
C. Alan Blackman, "Our Father," inspired by the work of British artist
Gordon Onslow-Ford, gouache, 20 x 26"
D. Rose Folsom, "Barefoot Summer," ink and pastel on paper, 51 x 88"

A. Timothy Botts, from *Windsongs* (Tyndale House, 1988), gouache and gold leaf on handmade paper
B. Bettye Lou Bennett, "Truth," gouache and sumi ink on watercolor paper
C. Carl Rohrs, "What is Calligraphy," Higgins sepia with Lebenzon brushes on white arc paper, 16 x 7"

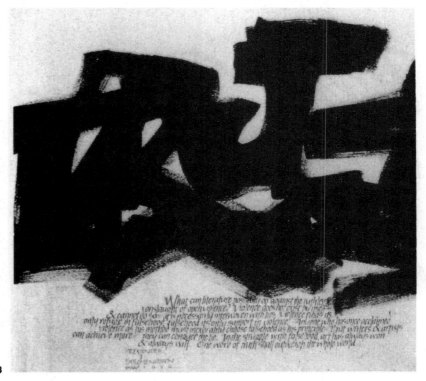

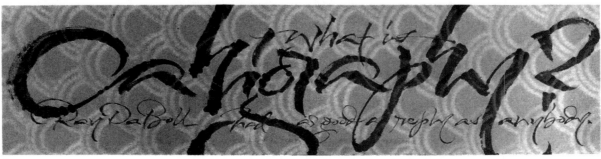

E

A *inklings*

B *Pasta Prima*

F

C *McCoy.*

D *the Macintosh Bible*

G the Remainders

H Attitudes

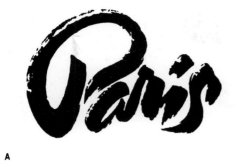

Paris

A

going

B

For My Wife

C

Hawaii Aikijutsu

D

the Best of times

E

with a delicate touch

F

Congratulations!

G

A. Sherry Bringham
B. Carl Rohrs
C. Lisa Rogers
D. Nancy Jang
E. Karen Charatan
F. Jenny Hunter Groat
G. Michael Williams

Index